Henry Ford
Mass production, Modernism and design

STUDIES IN
DESIGN
AND
MATERIAL
CULTURE

general editor
Paul Greenhalgh

Henry Ford
Mass production, Modernism and design

Ray Batchelor

MANCHESTER UNIVERSITY PRESS
Manchester and New York

distributed exclusively in the USA and Canada by St. Martin's Press

Copyright © Ray Batchelor 1994

Published by Manchester University Press
Oxford Road, Manchester M13 9NR, UK
and Room 400, 175 Fifth Avenue, New York, NY 10010, USA

Distributed exclusively in the USA and Canada
by St. Martin's Press, Inc., 175 Fifth Avenue, New York,
NY 10010, USA

British Library Cataloguing-in-Publication Data
A catalogue record is available from the British Library

Library of Congress Cataloging-in-Publication Data

Batchelor, Ray, 1954–
 Henry Ford, mass production, Modernism and design / Ray Batchelor.
 p. cm.
 Includes bibliographical references.
 ISBN 0–7190–4173–2. — ISBN 0–7190–4174–0 (pbk.)
 1. Ford, Henry. 1863–1947. 2. Industrialists—United States—
Biography. 3. Automobile industry and trade—United States—History.
4. Automobiles—United States—Design and construction—History. 5. Mass
production—United States—History. I. Title.
II. Title: Henry Ford.
HD9710.U52F662 1994
338.7'6292'092—dc20
[B]
 94–22346
 CIP

 ISBN 0 7190 4173 2 *hardback*
 0 7190 4174 0 *paperback*

Printed in Great Britain
by Redwood Books, Trowbridge

Contents

Plates

Black and white

Colour

the colourplates appear between pages 86 *and* 87

Acknowledgements

I should like to thank my editors Paul Greenhalgh and, at Manchester University Press, Katharine Reeve as well as her colleagues Hannah Freeman and Jane Hammond Foster for their patience during the preparation of this book; also Buckinghamshire College, a college of Brunel University, for funding a sabbatical semester during which most of the work was written and for their direct sponsorship, which has enabled colour plates to be included; John Staudenmaier SJ for his thoughtful letters; Andru Layke for his invaluable help in compiling the notes and bibliography; Margaret Matthias, Brendan James and Peter Hinchcliffe for their help in preparing the illustrations; Christine O'Brien for her sympathetic copy-editing; Annelise Jespersen for lending me her books; and for support in many valuable forms, John Liffen, John Styles, Charles Saumarez-Smith, Penny Sparke, Graham Walker, Dominic Stone and John Steer.

Finally, I must warmly thank all those people who, like many of those mentioned above, patiently listened to me while I talked and whose timely, perceptive criticisms have helped to make this a better book.

Illustration credits:

Numbers refer to pages; plates are colourplates.
The Philadelphia Museum of Art, Philadelphia, 3; Henry Ford Museum, The Edison Institute, Dearborn, Michigan, 10, 12, 17, 21, 23, 25, 28, 29, 34, 35, 37, 40, 45, 46, 47, 51, 54, 61, Plate III; Albert Kahn Associates, Detroit, 59; The Lane Collection, photo courtesy of Museum of Fine Arts, Boston, 63; Ford and Earl Design Associates, 71; General Motors, Photo Services, Detroit, 84; Grand Rapids Public Library, Michigan, 94; Bauhaus Archiv, Berlin, 96 (bottom), 100, Plate V; Lucien Hervé, Paris, 97; American Airlines, 104; Mrs Raymond Loewy, Monte Carlo, 105; URLA, Paris, 106 (both); Museum of Modern Art, Film Stills Archive, New York, 107; F. R. Yerbury and the Architectural Association, London, 109; Harry Ransome Research Center, The University of Austin at Texas, Theater Arts Collection, 114; Corporation of London, Greater London Record Office and History Library (Photographs), 113, 119; Joseph E. Seagram and Sons Inc., New York, 118; British Radio and Electronic Equipment Manufacturers Association, 125; Prestel-Verlag, Munich, 137 (top); Transform, London, 137 (bottom); EMAP National Publications Ltd, 139, Plate IV; Bundesarchiv, Koblenz, Plate I; Ford Motor Company, Brentwood, Essex, Plates III, VII; H. Randolph Lever Fund, The Brooklyn Museum, New York, Plate VI; E&S Retail Ltd., Ipswich, Plate VIII.

General editor's foreword

The range of texts in this series has been limited neither by the social status of the objects concerned, nor by their production methods. There are volumes on mass-produced commodities designed as low-value disposables, as well as on exclusive products designed for a very rarefied usage. Objects are designed to fulfil a myriad of roles; the series seeks to reflect that in the subjects it deals with.

Henry Ford is one of the twentieth century's enduring legends. The purpose of this volume is to re-examine from a late twentieth century perspective the man, the myths which surrounded him, his times and his contribution to manufacturing technology as well as re-assessing the consequences of mass production for design.

On the one hand, there is the technology. The distance between Ford's legendary achievements and the reality of what actually occurred has been the focus of much recent research. This work traces how Ford's particular model of mass production had to be modified to accommodate circumstances far removed in time and space from early twentieth century Detroit. The car industry, from its earliest beginnings to its present, sophisticated configuration, is reconsidered in an illuminating case study.

Yet the consequences of mass production for design cannot be confined to technology alone, for technical realities are matched by a range of abstract concepts. Some provided foundation stones for Modernist theory. A movement which deified the machine, attributed the profoundest significance to mass production. It was said to refine form and could, perhaps, provide a rational, orderly basis for an authentically twentieth century aesthetic. At the other extreme, the attitude of the masses towards mass production has seldom been enthusiastic. It was they, after all, who could appreciate at first hand the monotony of the production line. To describe a thing as 'mass-produced' is popularly understood as an insult. Throughout this century, manufacturers, designers and retailers have been obliged to address these changing perceptions, not least, through the designs of the products they offer. And what we actually do with those products resembles some of Ford's extra-industrial activities, as he responded to the changing world in which he found himself and which he had helped to create.

For Jeffrey

Introduction

In 1935, Noel Carrington was anxious about the role of fantasy in Henry Ford's, and everybody else's lives:

> We feel the need of getting away from real life, and this is shown by the fact that the business men and manufacturers are just those who fall most easily to the old-world trappings out of their offices and factories – Mr. Ford and his reconstructed English village [*sic*] and Mr. Hearst with his fantastic castle, returning to the fairy tales of their youth – but we cannot afford to laugh at transatlantic millionaires, for nearly all of us gratify this 'back to childhood' desire to the extent of our means. It is an unescapable fact none the less that all such glorification of the past [or any other form of escape presumably] contains within it the danger of impaired vision for the present and for the future. Design is *thought in time* as well as in space.[1]

Henry Ford was not an educated man. 'History is bunk!' he is said to have famously fumed in 1916, in the course of a humiliating libel case he brought against the *Chicago Tribune*. In fact the paper itself quoted him as follows: 'History is more or less bunk. It's tradition. We don't want tradition. We want to live in the present, and the only history that is worth a tinker's damn is the history we make today.'[2] In practice, Ford proved to be not only the Modern man of the *Tribune's* account, but an innovative historian. His belief in the powers of technology to resolve countless economic and social problems was at one with many of the tenets of Modernism, as were his apparent contempt for orthodox accounts of or respect for the past and his eager desire for reality to be rooted in the present. How, then, did he come to warrant Carrington's charge that he had retreated into fantasy?

By 1916, he was well on his way to becoming one of the most famous men of the twentieth century. He had got there chiefly by doing things as they had not been done before. Principally, under his guidance, a range of manufacturing techniques which had been evolving for more than a

century and a half were brought together, modified, added to (and sometimes discarded), bringing mass production to its most extreme form. The product of this new machinery was another innovation: the Model T – a car for the masses. This too was making history and changing lives even as he spoke to the *Tribune* journalist. As in technology, so in countless other areas, Ford was a proposer of radical solutions.

At Greenfield Village – the collection of old American buildings (plus a couple from England) which Ford had assembled – he was promoting an alternative to the, then, conventional view of history, which laid emphasis on political and military events, while ignoring the experiences of everyday life. In the fullest sense, he was contributing to 'the history we make today'. But in making that history, he proved no less susceptible to the temptations of editorialisation than the conventional historians he disdained.

Ever since material goods began to be supplied in quantity through the agency of the machine, there has been anxiety about the uses to which the masses might put them. How could rank, status or moral worth be readily identified, if the material trappings with which these qualities were previously identified became promiscuously available to the masses? The Arts and Crafts Movement supplied one handy criterion by which the problem could be solved: if something was made by machine, it was not moral and, in terms of the nature of humanity, not authentic. Mechanical replication was not authentic. Once it became plain that the masses had a greater appetite for the products of mass production than they did for the fastidious niceties of Arts and Craft 'hand-made', the Modern Movement turned the argument on its head. Products would only be deemed authentic if they were expressive of the machine character of their origins; all else was pronounced immoral and inauthentic. Needless to say, the Moderns – especially the critics – took for themselves the powers of arbitration.

Carrington, whose diagnosis is more cautious than many, was echoing a contemporary Modern concern: mass production was creating a staggering variety of goods which catered for escapism. Escapism diverted attention from the technological reality which Modernists believed they had identified. Both Ford and the masses were guilty of self-indulgence. The Moderns themselves failed accurately to acknowledge or permit the role which illusion, fantasy and fiction play in all our lives.

Today, the lot of the poor in the west seems to be deteriorating, while

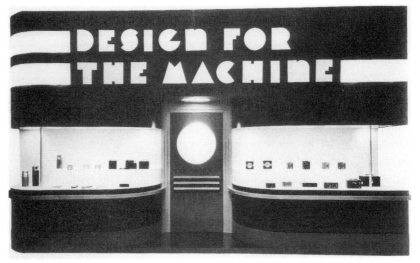

A shop front for the Design for the Machine Exhibition, Philadelphia Museum of Art, 1932. What should machine-made objects look like? Like many designers in the ensuing years, Teague made use of forms that implied the precision and simplicity which, it was then believed, machine production demanded. Here, streamlining implies effortless dynamism. The machine was to restore harmony.

the general availability of material goods continues to rise. Where previous generations criticised shopping in conventional moral, political and economic frameworks – with the 'high debate' of Modern design as an interesting sideshow – today there are two new ethical concerns which inform the argument. Firstly, the environmental lobby has given voice to growing anxiety about the demands which services and industrial production – including mass production – make on natural resources. In parallel with this, questions are also raised about consumerism – an inordinate attachment to the activities of shopping and possession of material goods – which is now everywhere identified. Consumerism, the argument goes, places too much emphasis on individual fulfillment and too little on collective responsibility.

Interestingly, despite the column inches devoted to it in the 'quality' newspapers, consumerism seems to afflict only other people, and not ourselves. What *we* own, wear, drive, listen to or watch, play with or enjoy is seldom as morally destructive as that which other people make

such craven use of. Are outrage at consumerism and aspects of environmentalism the new moral canon by which the activities of shopping and the enjoyment of material goods are to be policed? Perhaps. Perhaps they may also, in some respects, represent a contemporary expression of the fear experienced by the educated, privileged – and materially supplied – of the purposes to which other people might put their increased material plenty. The accusation of vulgarity, never far from the lips of high debaters from the Arts and Crafts Movement onwards, is still to be heard, if only as a whisper in the louder clamour.

Consumerism – to the limited extent that it exists – cannot be defended. Yet it is surely a symptom of some deeper malaise, rather than its source. Indeed, it might be argued that by devoting so much attention to criticising the act of shopping, it is the consumerism debate itself which is diverting intellectual energies from the wider collective sphere of politics, where the real evils are ultimately to be resolved. Making shopping moral is an act of the self-obsessed and solves little.

The purpose of the present volume is to assess how events and ideas which originated in Ford's lifetime and sometimes with Ford himself have affected our lives today. In Part I, an account is given of Ford, the man, his character and his responses to the changing world in which he lived and to which he contributed. In a work of this size, it would be impossible to examine in detail the ways in which the technology of mass production spread from motor car manufacture into countless other provinces of industry. Therefore, the focus here is on the technology employed in the car industry in the twentieth century as representing mass production's most emblematic manifestation. Within obvious limits, much that has pertained there, has been the case in other fields.

Inevitably, in any work which addresses mass production, some definition of the term is required unless confusion is to reign. In different contexts, it is freely invoked to mean quite incompatible things. For example, Robert Lacey wrote in 1986: 'Mass production was a long-established tradition in American industry: Singer sewing machines, McCormick reapers, the small-arms manufacturing of Samuel Colt. Now Ford [was] proposing to apply mass production to the car industry for the first time'.[3] Ford would not have agreed. He claimed that, 'In origin, mass production is American and recent,' by which he meant that it belonged to the twentieth rather than to the nineteenth century.[4] Through William J. Cameron, one of his literary 'collaborators', he asserted that

Mass production is not merely quantity production, for this may be had with none of the requisites of mass production. Nor is it merely machine production, which also may exist without any resemblance to mass production. Mass production is the focusing upon a manufacturing project of the principles of *power, accuracy, economy, system, continuity and speed.*[5] [Emphasis added]

Lacey is using the term in its loose commonplace sense. Ford's definition is much narrower and more precise. Two years before Lacey's biography of Ford, David Hounshell in his detailed account of the evolution of American manufacturing technology more or less adheres to Ford's definition. Mass production 'in the fullest sense of the expression', writes Hounshell, means 'single-purpose manufacture combined with the smooth flow of materials; the assembly line; large volume production; high wages . . . and low prices.'[6] The usefulness of a stricter definition is that it enables specialists to discuss mass production in more precise terms; what it cannot do is acknowledge the validity of looser, more emotive definitions and the extent to which they have altered the ways people think.

In trying to assess the consequences of mass production for design, the strict definition alone is not enough. For the purposes of this volume, a range of definitions will be employed according to the objectives pursued. 'Fordism', the term by which Ford's narrowly defined mass production was first known is the phenomenon examined in chapter two. In these terms, Ford is seen, not only as the first to practice it, but also the last. Mass production 'as Ford had made it and defined it was, for all intents and purposes, dead by 1926,'[7] asserts Hounshell. In chapter three, the extent to which others adhered to or altered Ford's practices is explored.

In the second part of the book, the emphasis shifts from the technology itself to the mythologies which arose around it. Chapter four examines how abstract ideas of mass production affected design. In this context, looser definitions are detailed at the outset and elaborated as the enquiry unfolds. Finally, in chapter five, which looks at mass production today, technical and abstract definitions are explored in turn.

Throughout the twentieth century, key ideas about mass production have been embraced, developed or rejected by manufacturers, designers and critics, as well as by the purchasers of industrially made goods. These ideas were vital ingredients in both the construction of the Modernist vision and its subsequent collapse. By assessing the consequences of this process over time, a clearer picture emerges of the nature of our own world and, by implication, the roles we may expect design to play in our lives.

Henry Ford

Notes

1 Noel Carrington, *Design and a changing civilisation* (London, 1935), p. 86.
2 Quoted by Robert Lacey, *Ford, the men and the machine* (London, 1986), p. 238.
3 Lacey, *Ford*, pp. 88–9; see also pp. 103–4.
4 From the *Encyclopaedia Britannica* (1926), the entry for 'Mass Production', ostensibly by Ford himself but almost certainly written by William J. Cameron, one of Ford's ghost-writers; quoted by Hounshell, *From the American System to Mass Production, 1800–1932* (Baltimore and London, 1984), p. 3.
5 *Encyclopaedia Britannica* (1926), quoted by Hounshell, *From the American System*, p. 217.
6 Hounshell, *From the American System*, p. 263.
7 Hounshell, *From the American System*, p. 12.

Part I

The twentieth-century manufacturer

1 The Modern American folk hero

President Hoover took Thomas Edison's arm, as the politician helped the frail inventor off the train at Smiths Creek Depot. In 1863, the young, unknown Edison had been forcibly ejected onto the station by a railway official, who took exception to the boy's chemical experiments when they led to a merry blaze in the baggage car. Now the inventor was neither young nor unknown; the steam locomotive had to compete with the automobile; and Smiths Creek Depot, despite looking almost exactly as it had more than sixty years earlier, was no longer at Smiths Creek. The two men were to be the guests of Henry Ford. Others on the invitation list included Orville Wright, Marie Curie, John D. Rockefeller Jr. and Will Rogers. All of them came.

They were attending the inauguration of Greenfield Village, an eclectic collection of mostly eighteenth- and nineteenth-century buildings which had been dismantled, transported and re-erected on this 252-acre site at the industrialist's personal expense. The Depot was but one example. Nearby, in the Henry Ford Museum, was a steadily growing collection of old machinery. Millions of Americans listened to the proceedings, live, as they happened, including a contribution by Albert Einstein talking to them by radio from Germany.[1] Ford said,

> When we are through, we shall have reproduced American life as lived; and that, I think, is the best way of preserving at least a part of our history and tradition. For by looking at things people used and that show the way they lived, a truer impression can be gained than could be had in a month of reading – even if there were books whose author[s] had the facilities to discover the minute details of the older life.[2]

Though neither village nor museum were complete at that date, Ford devoted an enormous amount of time, money and care to the project throughout the rest of his long life. Visitors can still visit it today. At its heart is the village green, with a pretty brick and white-painted timber

The twentieth-century manufacturer

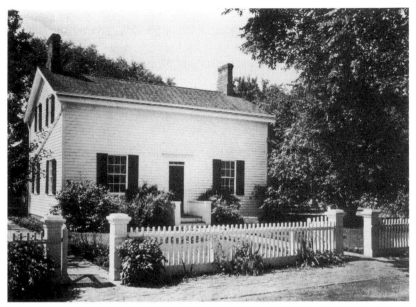

The (reasonably) humble home. Ford had it moved from its original site in 1919, when it was threatened by a road-widening scheme, and eventually incorporated it into Greenfield Village. This immaculate building is the birthplace of a hero in the mythic sense only.

church at one end, and an inn, town hall, courthouse, school, shops and offices ranged around it. Along the other streets are homes and shops of various types, ages and pretensions; most of them are humble. Here is a small bicycle store opened in 1892; opposite, a jewellery and watch-maker's store; elsewhere there are two more; there are two blacksmith's shops as well as the workshops of other artisans, a number of sawmills and some small factories. The ignorant visitor might wonder why this American village included a substantial stone house from the Cotswolds in the West of England, the 'Rose Cottage' of the guidebooks; or what sort of community would have supported the numerous laboratories dotted about and three watchmakers, but no bank; or why, just outside the village, the Henry Ford Museum buildings – which house, among other things, a vast array of machinery from farm implements to aircraft – resemble Philadelphia's Independence Hall, Carpenter's Hall and Old City Hall arranged as one composition.

Greenfield Village is not a particular village captured at a particular

time in its history. It was intended, instead, to be emblematic of a way of life: the small town, rural life into which Ford had been born at about the same time as Edison's incendiary excursions. Ford deeply lamented the rapidity with which that world was being erased and transformed, and sought to perpetuate its values in the Modern world. At the same time, the enterprise was to celebrate the growth of native American technological and industrial prowess and the individuals associated with it. These old-fashioned values and these individuals had, Ford thought, made America great.

'Rose Cottage' represents the Old World the early pioneers had left behind. The Plympton and Susquehanna houses and the Cape Cod Windmill represent the early New England phase of European settlement in America. Here is the home of Noah Webster of the 1828 dictionary. The composer of 'Oh Susanna', 'Beautiful Dreamer' and 'Old Folks at Home', Stephen Foster was, we are told, born in 1826 in this more modest structure removed from Pittsburgh. Here is Edison's Menlo Park, where from 1876 to 1886 the prolific inventor had established one of the world's first research laboratories and developed the cardboard filament light bulb, the phonograph and the carbon telephone transmitter, magically whisked from New Jersey to Greenfield Village, Michigan. The bicycle shop from Dayton, Ohio, had belonged to Wilbur and Orville Wright. The clapboard house next to it was their home, complete with a porch added by the brothers themselves. Being obliged to pass through exact replicas of historic Philadelphia buildings on their way to the machinery exhibits, visitors are left in no doubt: these machines are American history.

But Ford's desire to honour rural America and the nation's technological innovators cannot in itself explain the millions of dollars nor, more importantly, the passion which he brought to the undertaking. As early as 1919, Ford had set about resiting and refurbishing his childhood home when, ironically, it became threatened by a roadway development.[3] More than anything else, Greenfield Village represents an attempt to formalise the obsessive desire which Ford developed in middle and old age to document, authenticate and, in a sense, vindicate his own life by proving that it was simultaneously typical, exceptional, American and heroic.

Having passed the entrance gate to Greenfield Village, it is Ford's father's barn which is first seen. Then, opposite on the right, is the house where Ford was born, the house kept by his mother whom he idolised and who died when he was only twelve. Upstairs in Ford's boyhood bedroom is a complete watchmaker's bench where the young, mechanically skilled

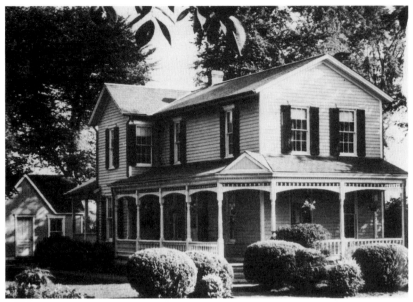

The home of the Wright brothers, originally at Dayton, Ohio, rebuilt at Greenfield Village. Ford sought to show an account of American history where small-town, rural life and values, as well as American technological knowhow were celebrated. The ordinary, everyday artifact became sanctified by associations with heroes.

prodigy mended the neighbourhood's watches and clocks. Greenfield Village has three watchmaker's shops because Henry Ford liked them; equally, there are no banks because the millionaire distrusted them. The schoolhouse on the Green is the same schoolhouse he attended, complete with a dunce's cap, willow cane and Ford's beloved McGuffy readers – dramatically illustrated tracts which instructed a generation of nineteenth century American youth in self-reliance and how to differentiate unambiguously between right and wrong. On the wall of the school hangs the red, white and blue of the stars and stripes. In the Ford archives is a dance programme on which is printed in gothic script, 'New Year's Ball, January 1st 1885'. Above the text is a steel engraving of the Martindale House, an eminently respectable hostelry with a restaurant and ballroom, where, on that very date, Henry first met Clara Jane Bryant, the future Mrs Ford.

If the values of rural America were really important, the tangible

evidence of that way of life needed to be preserved. The frontiersman, the settler farmer or rancher carving out an existence were the familiar American folk heroes who represented these values. As America industrialised, the canon was modified to include the Yankee mechanic, the native mechanical, inventive genius. Edison and the Wright brothers were inventors; Ford, whatever his remarkable mechanical talents was primarily an industrialist. In an age when the movies were enabling the cowboy to elbow into their company, could an industrialist – albeit the most spectacularly successful one the world had ever seen – keep company with other Modern American folk heroes? A reliquary of commonplace artefacts, made great by those who touched, used, lived or worked in them could only strengthen the cult; and by literally making an exhibit of his own past, Ford was having a say in what is and what is not American history and making quite sure that at least one version of it existed where Henry Ford, in suitably august company, was at the centre. Greenfield Village is an autobiographical document as telling as *My Life and Work* published in 1922, or any other of the ghosted writings he lent his name to, and possibly more so. It is certainly just as suspect.

The actual location, timing and circumstances of his birth would seem a near ideal past for an American hero. He was born on 30 July 1863 at Dearbornville, Michigan. Michigan at this time had only recently graduated from territory to state of the union and had been part of the 'frontier' well within living memory. Ford was part of the first American-born generation of a family which had first arrived from Ireland in 1832, attracted by the prospect of cheap land. In the construction of an American hero, humble origins are invariably to be desired.[4] However, in Ford's case, it would be a mistake to paint a picture of poverty. His parents, William Ford and Mary Litogot were, by the standards of the time and place, modestly respectable, and the Ford clan owned several hundred acres at Dearborn.

Shortly after his mother's death, Ford and his father were out riding in a horse-drawn wagon. Coming towards them was the kind of plain, working steam engine increasingly used by farmers. Ford had only seen stationary engines before, drawn by horse to the place where they would be used, but the owner of this machine had improvised an arrangement whereby the engine powered the rear wheels of the wagon. Henry Ford was, he recalled later, captivated.[5]

Ford confided to Samuel Crowther, the journalist who collaborated

with him on *My Life and Work*, that his father was anxious for him to stay on the farm in Dearborn and discouraged his mechanical exploits to such an extent that Ford had to mend his watches in secret, hence the bench in the bedroom. In old age, Henry's younger sister Margaret, a woman with no especial axes to grind, maintained that accounts of her brother's life – for which Ford himself was often the source – embroidered the juvenile years with stories of exaggerated hardship and dramatic technological prowess. And there never was a watchmaker's bench in Henry's bedroom, she said.[6]

We read in Allan L. Benson's *The New Henry Ford*, published in 1923:

> Thus for a time the struggle went on between the father's will and the son's determination. One day, when the boy was 16 the struggle ended. The mother had died three years before, the old home did not seem the same, and the call of the city silenced everything else in the boy's heart. Without saying a word to anyone, he walked 9 miles to Detroit, rented a room in which to sleep, and sought employment in a machine shop.[7]

According to Ford, he languished at first as an apprentice at the Drydock Engine Works.[8] Yet in an account drawn up in 1914, Ford said his first work was at the Flower Brothers machine shop.

Margaret wrote,

> Father never forbade him to repair neighbor's watches . . . Since father was handy with tools, he was very proud that Henry had inherited his ability to fix things . . . Father was quick to recognise Henry's ability in making new things. He was very understanding of Henry's demands for new tools for the [work]shop and ours was one of the best equipped in the neighbourhood.[9]

In 1876, William Ford had taken the trouble to visit the Centennial Exhibition at Philadelphia, where mechanical marvels abounded. Similarly, the man who was among those who voted in favour of the introduction of streetcars to Dearborn would seem an unlikely candidate for the role of backward-looking father, distrustful of technology and the big city. Moreover, the Flower brothers were personal friends. William Ford was responsible for securing his son's first job as a mechanic.[10]

Robert Lacey in his book *Ford, the men and the machine* suggests that Henry's unflattering account of his father may have sprung from his adolescent feelings about his father's role in his mother's death. She had died in the aftermath of a miscarriage. Ford was deeply attached to his mother

and in later life venerated her memory beyond all others. This may, indeed, have been part of the explanation. But, these numerous, apparently trivial discrepancies in accounts of Ford's early life also serve to reveal something of his later estimation of his rightful position in American history. When Ford gave interviews to Crowther and Benson, he was at the height of his fame as the creator of mass production, the man who introduced the revolutionary $5-a-day wages for Ford workers – more than twice their previous pay – and, above all, the creator of millions of Ford Model Ts, the car that had become an emblem of this young, rapidly modernising, democratic country. Increasingly, he was seen as a Modern American folk hero. Indeed, the years mark a period when he was pursuing his tacitly acknowledged but undeclared candidacy for the presidency of the United States. At the same time as he was developing ideas about American history, which were later embodied in Greenfield Village, he was busy exploiting books and newspapers as well as radio and the movies to create for himself an artificial personal history more in keeping with his emerging mythic status.

This is the point at which the young Ford first forsook the country for the city. It was an act duplicated by millions of Americans. The way of life which Ford revered – even if it never existed in precisely the form he believed – was similarly revered by them. The Modern American folk hero was, in part, a symptom of a nation adjusting to the discrepancies between a remembered rural ideal and a rapidly changing and unsettling industrial urban reality. Yet the democratisation of personal transport, for which Ford perhaps more than anyone else had been responsible, precipitated not only the most dramatic physical transformation of the country, but fundamental social upheavals as well. In short, he helped destroy the very way of life, the passing of which he now lamented. This was one of the fundamental paradoxes of his life. The successful Modern American folk hero needed to wrestle with and reconcile paradoxes of this sort on the American people's behalf. Ford tried and, at the level of myth, seemed largely successful. Thus, in making an escape from his father's hostility and conventional outlook and setting forth for the unknown frontier of the city and mechanical adventure, the hero takes command of his own destiny in an immediately recognisable form. Being helped by your father and your father's friends provides insufficient drama, and freely to forsake the idyll would be, at best, an uncharacteristically ambiguous decision and, at worst, a near culpable act.

In the event, Ford's departure for Detroit in 1879 may have marked the

end of his youth, but it did not mark the end of his 'real' life in the country. In 1882, having completed his apprenticeship, he returned to Dearborn. Eventually he settled down to life as the South Michigan demonstrator and repairman for Westinghouse steam engines – the agricultural sort by which he had been impressed as a boy. It was a good life with position, respect and comfortable remuneration. In 1888 he married Clara, who always maintained that at their first meeting, commemorated by the tasselled dance programme in the Ford Archive, the young man made no impression on her whatsoever. The programme itself is a twentieth-century creation.

Ford was a middle-aged man before the achievements for which he became famous were accomplished. His career in the years leading up to success was somewhat erratic. In early married life he was a farmer to the extent that he and Clara grew vegetables and kept livestock for their own needs, but his real income came from other activities. He earned money clearing trees for local farmers using steam-powered machinery and selling the timber; he installed and repaired 'Eclipse' portable farm engines on behalf of the Buckeye Harvesting Company. Then in 1891, Ford secured employment for himself as a mechanic-engineer at a Detroit substation of the Edison Illuminating Company. On the strength of the promised $45 salary a month, Henry persuaded a reluctant Clara to leave the country, and in September they both moved to Detroit.[11]

Increasingly his changes of employment became a reflection of his enthusiasm for mechanical experimentation. Earlier in 1891, at a Detroit soda bottling plant, Ford had seen and been impressed by a 'four stroke' internal combustion engine. Nikolaus Otto had invented an engine powered by gas, which was – in comparison with steam engines – silent, efficient and, for its size, powerful. From the first, Ford speculated as to how it could be adapted to propel itself. His knowledge and understanding of steam engines was extensive, but he knew next to nothing about electricity, a central element in these revolutionary power units. The move to live in Detroit and work for the Edison Illuminating Company had arisen, in part, as a result of his desire to learn about electricity.[12]

Ford did not invent the motor car. Like the internal combustion engine, it was of European origin – even if historians disagree about which particular European deserves the credit. One of Otto's colleagues, Gottlieb Daimler, adapted the Otto engine to run on petrol rather than gas, and petrol engines were at the heart of his own and Karl Benz's first motor cars developed in Germany around 1885 or 1886. At the time Ford was

Ford in his twenties, back row, third from the right. Ford left rural Dearborn for Detroit to manage one of the Edison Illuminating Company's power plants. The plant, together with other buildings and objects from his life, were later assembled at Greenfield Village, Ford's creative and occasionally suspect synthesis of history and autobiography.

imagining how the power unit at the bottling plant might be adapted to power a vehicle, there were still no motor cars in America. Charles and Frank Duryea publicly demonstrated their petrol-powered 'horseless carriage' at Springfield, Massachusetts in 1893; and in 1895, the invention in its rough, early forms was brought dramatically to the American public's attention in a race organised by the *Chicago Herald-Tribune*.[13]

Ford had not been idle. His work at the Edison Illuminating Company had gone well and was appreciated by his employers. Skills began to emerge which were later to prove of consequence in the development of mass production. He introduced a range of minor, but effective, technical innovations as far as maintenance of the machinery was concerned; more significantly, he simplified procedures, eliminating any tasks performed more out of habit than necessity; and, given the opportunity to run his own station, he organised matters in ways which ensured a thoroughly smooth-running operation. Ford's salary increased as he was promoted, and his employers allowed him a certain amount of freedom at work.

The twentieth-century manufacturer

With routine maintenance, a properly organised plant should more or less run itself. Ford was allowed to use space in the plant as a sort of private workshop where he could tinker with personal projects.

He decided to make an internal combustion engine out of scrap. Frederick Strauss, who worked with him, commented on a personal quality which was to be of great importance in the development of mass production as well as in Ford's subsequent dealings with the world: his ability to engage with and enthuse others. 'Saturday nights we had quite a crowd. Henry had some sort of magnet. He could draw people to him; that was a funny thing about him.' At the Edison plant, those whom Ford drew around him were young, talented mechanics. Gas engines and motor cars were in the early stages of their development. Ford and his colleagues may not have been inventors, but by constructing an internal combustion engine from scratch on the basis of limited first-hand experience and articles in popular mechanical magazines such as *The American Machinist*, they were finding out about and developing a technology which was new and exciting and which offered countless opportunities for innovation.

Ford's mechanical tinkerings may have been directed more specifically towards the development of a motor car by his acquaintance with a horseless carriage enthusiast, Charles B. King. In March 1896, King's vehicle was demonstrated to press and public. This large wooden wagon with a four-cylinder engine processed at a stately five miles an hour with Henry Ford cycling beside it. Meanwhile with colleagues from the Edison plant, Ford had been developing a car of his own in a small brick shed at the back of his home. In June, the aptly named Quadricycle took to the streets for the first time. Smaller and less powerful than King's offering, it was also much lighter; consequently the power-to-weight ratio made it faster, capable of some twenty miles an hour.

Perhaps the main difference between Ford's Quadricycle and King's automobile was that King was designing for the limited market that existed in 1896: his aim was to produce a horseless carriage that was a plaything for the rich. What else could it be? Ford, on the other hand, seems to have designed a car with himself or people like himself, rather than the carriage-owning classes, in mind. A second vehicle was constructed between 1897 and 1898. This was somewhat larger and more robust and practical. It also looked more plausible as a reliable means of transport. With solid financial backing from a group of the city's wealthiest entrepreneurs, Detroit's first car company, the Detroit Automobile Company, was founded in August 1899 with Ford as mechanical

superintendent. But his ascent to the position of motor manufacturer was not to be smooth. By 1901, the business was wound up.

Ford then embarked on a brief but successful career as a racing driver. Victory in a race at Grosse Point brought him sufficient kudos to secure backing for a second company, the Henry Ford Motor Company, founded just seven weeks later. Many invested who had already lost money financing the Detroit Automobile Company. The intention – of the backers at least – was to start making a car based on the one which had been responsible for Ford's famous racing victory. Yet only four months later, Ford was asked to leave and offered a severance payment of $900. The company was renamed the Cadillac Automobile Company and manufactured a car according to Ford's design, but with a single, rather than a two-cylinder motor. After 1909, as part of General Motors, Ford's arch rivals in later years, Cadillac became one of America's most prestigious makes of motor car – the exact opposite of the reputation Ford motor cars subsequently acquired.

Ford's later accounts of his relationships with his financial backers in these early years invariably hint at their avarice and short-sightedness, their limited understanding of the auto business in general and of Ford's vision in particular. Yet this is almost certainly the hero speaking, with the hero's desire to revise the awkward details of history. Lacey points out that in the first venture Ford seems to have been overwhelmed at the prospect of organising a manufacturing programme, wandering off into the nearby woods 'designing' for long periods and asking subordinates to cover his absences. In the second venture, he diverted resources from manufacture of the design in hand to the development of another racing car. Racing preoccupied Ford for some time. He constructed the '999', a brute of a car successfully driven by a former cycle racing champion, Barney Oldfield. But not only was Ford – fast approaching forty – not racing himself, he had been obliged to sell '999' before its first race, so the car, when it became famous, was not even his.

Ford's third and, as it transpired, last venture into motor car manufacturing began inauspiciously enough compared with the beginnings of his two previous failures. Firstly, its financial footing was nowhere near as secure. In 1902, he formed a partnership with a coal merchant, Alex Y. Malcomson. Malcomson was something of an entrepreneurial swashbuckler, investing here, there and everywhere and sufficiently mortgaged to want this latest venture concealed from his bank. Accordingly, he opened an account at another bank in the name of his chief clerk and cashier at

the coalyard, James Couzens. Couzens was to work with Ford. Character-istically, Malcomson brought little actual cash to the venture. Following the practice of most motor manufacturers at the time, the Ford Motor Company, as it became in 1903, was to buy in engines, transmissions, axles and other components and use the 'factory' as an assembly plant. Once orders for these parts had been placed, Malcomson's job was to raise capital, which he did. Couzens was a single-minded, humourless Canadian, but ruthless at keeping control over the financial arrangements – a vital factor given the precarious state of the finances. He, more than anyone else, ensured that Ford was not tempted to go 'designing' or tinkering with private projects. If the cars were not made and sold on schedule, the company would go under. The relationship between Couzens and Ford was odd but effective. From the first sale to a dentist in July 1903, demand was brisk.

Other models followed, each given a letter. Sometimes these differed little from one another. The Model K, however, was a top of the range, six-cylinder model, which Malcomson saw as the way forward for the company. Conventional wisdom held that more money was to be made per unit on luxury vehicles. Ford, who later claimed to despise the Model K, had other ideas. In 1905 he gave an interview to the *Detroit Journal* predicting 'Ten Thousand Autos at $400 Apiece'.[14] There was friction between the partners. Ford colluded with Malcomson's erstwhile clerk, and the coal merchant was ousted in 1906. By the following year, Ford was in complete control.

In 1907, he said,

> I want to build a motor car for the great multitude. It will be large enough for the family, but small enough for the individual to run and care for. It will be constructed of the best materials, by the best men to be hired, after the sim-plest designs that modern engineering can devise. But it will be so low in price that no man making a good salary will be unable to own one – and enjoy with his family the blessings of hours of pleasure in God's great open spaces.[15]

The hero is in rehearsal. The Model N had been intended from the first to be good value for money. Before production began in the spring of that year, Couzens had predicted it would cost only $450; in the event, with a four-cylinder engine in a car of reasonable lightness and strength, it was still competitive at $600. By concentrating on the Model N, annual profits increased to the point where they exceeded one million dollars for the first time.[16] But Ford believed that the formula – lightness, strength, power and

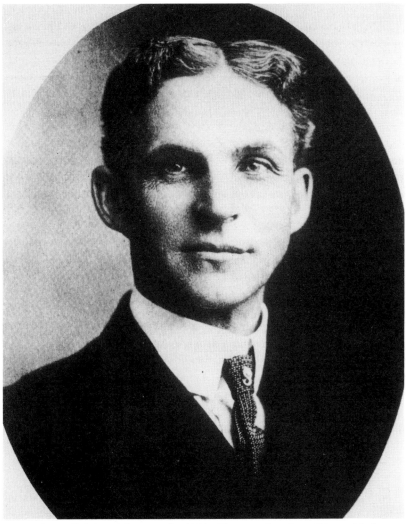

Ford's first official, public portrait, 1904. Clear-eyed and confident, this image of the co-proprietor of the Ford Motor Company betrays little of his two earlier disastrous forays into motor manufacture, or of the precarious beginnings of the present venture.

simplicity and a low price – could be better developed with a new model designed from scratch. Screens were erected to make a room on the top floor of the Piquette Avenue Factory. 'Home of the Celebrated Ford Automobiles' it said in large letters on the outside of the building. Together with the talented team he had assembled around him, Ford began work on the car which became more celebrated than any of its alphabetically identified antecedents.

In 1908, Ford was forty-five and, for the first time in his chequered career, apparently in control of his destiny. Demand for the Model T was strong from the first. The car was light and strong (thanks to the extensive use of vanadium steel), simple and, unlike its principal rivals, well powered. At $850, it was also competitively priced. With the move to the purpose-built Highland Park Factory early in 1910, all other models were dropped. The Model T became 'the Ford car'. The extraordinary demand for it meant that money poured in. Rather than allocating this income chiefly to dividends, Ford ensured that much of it was consistently ploughed back into the company. The experimenting which Ford had enjoyed at the Edison Illuminating Company and which in the past had seemed to jeopardise his future, now helped secure it. Similarly, his proven ability to orchestrate the talents of others proved invaluable. The mechanics surrounding him were young, talented, but not rooted in any one engineering tradition. Anything could change. Elaborate and expensive experimentation in the techniques of production became the norm. In the struggle to keep pace with the staggering demand, Ford and his mechanics revised and simplified production. The introduction of moving assembly lines in 1913 brought enormous increases in efficiency. Ford was able progressively to reduce the price of the Model T to $360 by 1916.[17] Each reduction in price increased demand.

Ford encouraged journalists to visit Highland Park and see for themselves how the thousands of cars were being made. A whole series of articles in popular magazines described and marvelled.[18] But if these were the physical achievements, journalistic reality demanded a personality to whom they could be attributed. Gradually, Ford began to assume the role of public figure. The process started modestly enough when he became the focus of attention during his legal battle with the Association of Licensed Automobile Manufacturers – a speculative patent cartel intent on controlling the industry. But Ford's role as an American folk hero proper was undoubtedly consolidated by the announcement that the

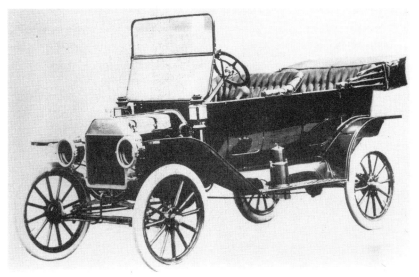

Model T tourer, 1914. After its introduction in 1908, staggering demand for this tough, simple car led to increasingly radical production innovations, including, from 1913 onwards, the assembly line. When production stopped in 1927, 15,000,000 had been made and like its author, the car had attained mythic status.

company was to increase the pay of its workers from a minimum of $2.34 to $5 a day. The statement released to journalists in January 1914 began modestly enough: 'The Ford Motor Co., the greatest and most successful automobile manufacturing company in the world, will, on Jan. 12, inaugurate the greatest revolution in the manner of rewards for its workers ever known to the industrial world.'[19] In addition to the unheard-of wages, Ford also announced a reduction in working hours from nine to eight a day. Both Couzens, who eventually pursued a career in politics, and Ford later spoke of the move as arising out of a desire to spread to the workers the good fortune that the company's phenomenal success had brought.[20] Perhaps this was so. More immediately, Ford workers hated the assembly line and were leaving in droves, offsetting a good portion of the economies it was supposed to deliver. Eight hours a day made it possible to have two shifts working each day, thus increasing efficiency still further. Then there was the immense value of the announcement in terms of free publicity. The Selden case had sharpened Ford's sense of the value of favourable news coverage. But whereas a legal case may have complexities

which might leave the public confused or bored, here, apparently, was a story at once startling and simple. The man who had brought practical personal transport within the reach of the 'ordinary American' and had presided over the development of production techniques which enabled him to cheapen and thus democratise his product still more, was now prepared, unasked, to share some $10,000,000[21] with his workers, making them wealthy enough, perhaps, to buy Model Ts of their own. From 1914 onwards the company spent virtually nothing on direct advertising; the publicity they were given through news stories and editorials stimulated more demand for their cars than they could easily meet.[22]

'GOD BLESS HENRY FORD', exhalted the *Algonac Courier*; 'A blinding rocket through the dark clouds of the present industrial depression,' asserted the *Cleveland Plain Dealer*; 'A lordly gift,' opined the *Toledo Blade*; 'A magnificent act of generosity,' was the judgement of the more metropolitan *New York Evening Post*. More than thirty stories concerning Ford appeared in the *New York Times* in the three months following the announcement.[23] Not all of them were favourable. The paper muttered of 'serious disturbances', while the *Wall Street Journal* echoed the fears of industrialists like the general manager of the Erie City Iron Works ('the most foolish thing ever attempted in the industrial world') when it predicted 'material, financial and factory disorganisation' as workers elsewhere responded to the dramatic announcement. The socialist *New York Daily People* suspected a capitalist scheme to obliterate competitors.[24]

However, attacks from right and left detracted little from public perception of the $5 day as audacious, bold, democratic and magnanimous. The triangular relationship between Ford, the press and the American public was thrown into top gear and remained there, more or less, until his death. From the earliest days of his relationship with the press, Ford exhibited little reluctance to pronounce on matters of politics or philosophy which were, perhaps, only tangentially linked to the business of car making. In the immediate wake of the $5 a day announcement, he was liberal with millionaire homespun: 'I think it is a disgrace to die rich', he said, and stories appeared across the nation exploring the theme. 'Goodwill is about the only fact there is in life. With it, a man can do and win almost anything. Without it he is practically powerless,' and so on.[25]

This mutually beneficial relationship had barely begun, before it was tested by the exigencies of the First World War. Popular opposition to involvement in the 'European war' ran high throughout its first months. Ford shared and rationalised popular distaste: 'I hate war, because war is

'GREAT WAR ENDS CHRISTMAS DAY: FORD TO STOP IT' scoffed a headline in 1915. Ford's attempt to stop the war in Europe with his 'Peace Ship' proved futile, but his failure added warmth and humanity to his publicly perceived characteristics.

murder, desolation and destruction, causeless, unjustifiable, cruel and heartless to those of the human race who do not want it, the countless millions, the workers. I hate it none the less for its waste, its uselessness, and the barriers it raises against progress.'[26]

Ford had achieved miracles in terms of car production which the world recognised and celebrated; could a similar radical audacity stop the war? Ford thought so and fell on the idea of sending a 'Peace Ship' to Europe with himself and a band of like-minded prominent people on a mission to explain to Europeans the folly of their ways. The scheme was prepared in immense haste, and sympathetic celebrities found themselves unable to join him. Clara was against him going at all and cried when the *Oscar II* pulled away from Hoboken pier as the bands played 'I Didn't Raise My Boy to Be a Soldier'. Nor had the press been enthusiastic: 'GREAT WAR ENDS CHRISTMAS DAY: FORD TO STOP IT', scoffed the *New York Herald Tribune*.[27]

Some were more charitable, using terms like 'quixotic', 'a wise maniac' and 'Jason of the Peace Argonauts' to describe him.[28] When the *Oscar II* reached Norway, the mission was in disarray. Ford stayed in his hotel bed with a severe chill, caught during the voyage. His hasty return to America should have been ignominious, but the *New York American*, as sceptical as other papers before the voyage, expressed a commonly held verdict on Ford's failure: 'No matter if he failed, he at least TRIED.'[29] Lofty motives and the fact of action outweighed failure to achieve the objective; this recently elevated American folk hero thus acquired a new humanity. But for Ford himself it was a painful check on the boundless optimism which had sprung from the Model T's spectacular success. As Wilson and the nation gradually came to the view that intervention was inevitable, so too did Ford. America entered the war in 1917. By 1918, the pacifist who had once declared he would rather see his factory burnt to the ground than have it produce armaments, solemnly promised to provide the nation with mass-produced Eagle submarines at no profit to himself.[30]

The failure of the Peace Ship had enhanced Ford's reputation for straightforward morality. Another episode which ought similarly to have damaged his heroic image, served instead to bolster it by identifying him more closely with popular perceptions as to the value of knowledge. In 1916, commenting on what transpired to be the misinformation that Ford workers called up for military service could not look to the company for job security, the *Chicago Tribune* described him as 'not merely an ignorant idealist, but an anarchistic enemy of the nation which protects him in his wealth.'[31] Ford sued for libel, but was poorly advised. Had his lawyers sued solely on the basis of the words 'anarchist' and 'anarchistic', the case could have been both strong and straightforward; instead they attacked the whole article, which provided counsel for the paper an opportunity to demonstrate Ford's ignorance. When the trial came to court in 1919, the nation read in its papers how, under cross-examination, Ford thought the American revolution occurred in 1812; that he did not know the meanings of the words 'commenced', 'ballyhoo' or 'chile con carne'. Those who wanted to, felt the time had come to sneer:

> The mystery is finally dispelled. Henry Ford is a Yankee mechanic pure and simple, quite uneducated, with a mind unable to 'bite' into any proposition outside of his automobile and tractor business, but with natural goodness and some sagacity. Enter any one of the great factories that line the railroad between New York and Boston and you will find a dozen foremen just like

Henry Ford, save that Fortune has poured no unending stream of gold into their laps. Many of them are better educated; many of them have more sagacity.[32]

The jury found in Ford's favour, but when asked to attach a monetary value to the difference between the *Tribune* portrait and the truth, they put it – not at the $1,000,000 Ford had sued for – but at six cents. Yet when papers like the *Nation* charged Ford with the 'crime' of being just like ordinary men, they shot themselves in the foot. Ford was not 'educated' to a high level in the formal sense; nor were millions of Americans. To sneer at him was to sneer at them. The reverse was also true. A Hearst journalist, Arthur Brisbane, in a column syndicated in rural papers invited readers to 'cut this out and mail it with your name signed: Dear Ford: I am glad to have you for a fellow citizen and I wish we had more of your brand of anarchism, if that is what it is. Yours truly: Sign here____ '.[33] Thousands of readers responded and the almost personal relationship which many Americans felt they had with 'Henry' was cemented still further.

With variations in intensity and mutations in actual detail, the pattern for Ford's public persona was set: by turns he was seen as the embodiment of native wit or the high-minded innocent, as the 'ordinary American' writ large or the almost supernaturally powerful, Christ-like saviour. His autobiography, *My Life and Work*, appeared in 1922 and became a runaway best-seller translated into twelve languages – including Russian – and Braille.[34] Ford's personal popularity was such that he toyed, rather publicly, with running for president in an article entitled 'If I were President' in *Colliers Weekly* in 1923. When he announced his intention to take over the controversial Tennessee river Muscle Shoals dam and nitrate project, there was a public campaign that he should be given the opportunity to do so. Ford's close personal identification with a rural perspective was genuine and deep-rooted, as was his earnest desire to see agriculture and industry reconciled. The manufacture of Fordson tractors from 1916 onwards was but one expression of this impulse. The Muscle Shoals project was tailor-made as a public relations exercise, embodying as it did opportunities to tame the elements of nature with feats of technology to the benefit of agriculture. Massive hydro-electric dams would generate cheap power principally for the farmers of Tennessee, who would also benefit from cheap nitrate fertilisers.

The anti-Semitic articles which appeared sporadically in the 1920s and 1930s in the Ford-financed and inspired *Dearborn Independent*, can also partly be explained, though never excused, by Ford's rural background.

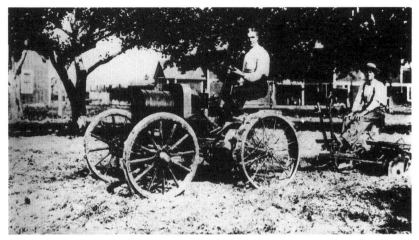

Henry Ford driving an experimental tractor, about 1908. Ford saw technology as a major force in assisting the farmers with whom he liked to be identified. The Fordson tractor was, perhaps, the most tangible, durable and successful expression of this desire.

In the 1880s when he was a young man, farming communities in the states of the Midwest, including Michigan, were struggling to come to terms with mechanisation and economic realities. As they mechanised productivity increased, but with more produce, prices fell. There was anger and incomprehension that each improvement the farmers introduced – including the agricultural steam engines which Ford tended – seemed to bring in less money, not more. This was seen, not as a consequence of their own actions in a free market, but the result of the avarice of others. Principal among the guilty were eastern bankers, city slickers and that convenient Old World scapegoat, the Jew.[35] Warning against the dangers of jazz, the *Dearborn Independent* told its readers in 1921 that the 'mush, the slush, the sly suggestion, the abandoned sensuousness of sliding notes are of Jewish origin'.[36] Quite what role black Americans – whose rights Ford championed from time to time – played in this decadence is not explained. Needless to say, jazz was part of an international conspiracy. Ford paid for copies to be printed of the *Protocols of the Learned Elders of Zion*, a forged document purporting to prove the existence of such a conspiracy. These were distributed throughout the world. In Germany in the 1920s, the German edition of *My Life and Work*, the *Protocols* and the *Dearborn Independent* anti-Semitic articles in book form were often

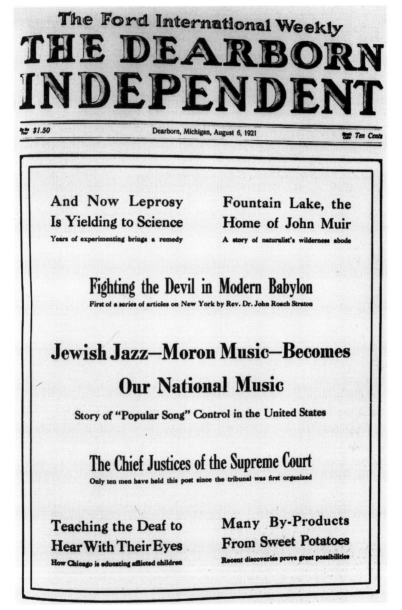

The Dearborn Independent. Financed and directed by Ford, it promoted the benefits of science, the natural world, education and advances in agriculture as well as peddling its proprietor's own casual anti-Semitism.

offered alongside one another. 'Every year makes them [the Jews] more and more the controlling masters of the producers in a nation of one hundred and twenty millions; only a single great man, Ford, to their fury, still maintains full independence,'[37] wrote Hitler, admiringly, in *Mein Kampf*.

Ford's anti-Semitism was, for the most part, curiously detached. He was genuinely surprised one year when a neighbour and family friend, Rabbi Leo Franklin, returned his annual gift of a new Model T after some particularly virulent anti-Semitic outbursts in the *Dearborn Independent*.[38] He was surprised again at the outrage which greeted his acceptance in 1938 of the highest honour that Hitler could award to foreigners. Since the earliest showings of newsreel film of the opening of the concentration camps, anti-Semitism has never been given public credence in the casual manner common before the advent of the Third Reich. When Ford, in his eighties, saw the newsreels, it brought on what proved to be his last and most serious stroke.[39]

Shortly after his opening of Greenfield Village, Wall Street crashed. Ford consulted with President Hoover and, amid great public excitement, announced the $7 day, cut the price of Ford motor cars and predicted a rapid recovery. But the magic, or rather, belief in the Ford magic looked as if it was receding. The rapid recovery never came. Ford tried other tactics: open letters advocating the virtues of 'family gardens'; a scheme for growing one's own vegetables he had tried with River Rouge workers; or, inevitably, closer co-operation between industry and agriculture. But the public was unimpressed. The Depression eventually caught up with the Ford Motor Company. By 1932, the $7 day had been quietly revised in stages to just $4. Visiting Dearborn in the spring of that year, the journalist Anne O'Hare McCormick commented, 'Something has happened to Ford, and perhaps through him to the America he represents.'[40]

That same year also witnessed the 'Dearborn Massacre', vivid proof, if proof were needed, that Ford labour relations had strayed far from the paternalistic idyll Ford had been peddling. Some 3,000 Ford workers, exasperated by the constant speeding up of the production line and several of Ford's more onerous labour practices, marched peacefully towards the River Rouge plant. At the Dearborn town line police tried to turn the marchers back. When reasoning failed to deter them, tear gas was fired. The confrontation escalated to the point where the police and Ford Service personnel – a sort of private police force – fired volleys of live ammunition.

Twenty-three marchers were shot, four of them fatally. A crowd of 15,000 turned up for their funerals.

Yet, as David Nye points out, despite everything, Ford's personal popularity endured. Only three weeks after the nation's front pages had been splashed with shocking details of the 'Dearborn Massacre', Ford presented the fruits of his last major feat of engineering and mass-market psychology: the Ford V8. On the launch day 6,000,000 Americans flocked to see it.[41] In a manner parallel to, if not on the scale of the Model T, Ford brought the power of a V8 engine within reach of 'ordinary Americans', and they loved it. Apart from giving birth to generations of 'hot-rods', it proved ideal for the professional needs of John Dillinger and Bonnie and Clyde.[42]

If Ford had seemed to embody all that was progressive in the 1920s when expansion was the norm, many Americans found the elderly, but energetic public figure of Ford, the old-fashioned, no-nonsense, ruralist conservative, comforting in times of uncertainty. Time and again the need for the mythic Ford triumphed over reality. On the 26 May 1937, the 'Battle of the Overpass' demonstrated still further the extent to which the ageing industrialist relied less and less on the paternalism of earlier more prosperous days and more on the strong arm tactics of his court jester and head of what was effectively an internal espionage service, Harry Bennett. In an ugly incident, thugs employed by Bennett beat unconscious prominent union organisers at a union rally outside the Rouge factory. Yet that very same month, when asked to choose from among a range of public figures, including other employers and politicians who had sponsored significant labour reforms, with the question 'Which of these people do you think have been on the whole helpful to labor . . .?' 73.6 per cent of the readers of *Fortune* who responded chose Ford.[43]

Production of the Model T had ceased in 1927 amid much public lamentation. Yet at the same time as the public rejected the reality of the car – sales had been dropping for years – they endowed it more and more with solid, mythic American virtues. In his much reprinted essay, 'Farewell My Lovely', E. B. White helped define the image by describing the car as,

> the miracle that God had wrought . . . As a vehicle, it was hard-working, commonplace, heroic; and it often seemed to transmit those qualities to the persons who rode in it . . . The days were golden, the nights were dim and strange . . . Boys used to veer them off the highway into a level pasture and run wild with them, as though they were cutting up with a girl.

As Nye observes, 'In this bucolic vision, the car was not an agent of change, but its victim.'[44]

Ford never ceased trying to reconcile agriculture and industry: he wanted to build cars – parts of them, at least – from soya beans. The teetotal, vegetarian had grown up in the age which entertained a whole range of dietary reforms, including Dr Kellogg and his cornflakes. Ford himself thought, among other things, that many bodily ailments were caused by the crystals in sugar.[45] In 1934, his dietary ambitions for the soya bean were publicly exemplified by a series of banquets at the Ford installation at the Chicago World's Fair. In what must have been challenging meals, all twelve courses featured some form of soya bean as its principal ingredient, washed down with cocoa and glasses of soya milk. Guests whose attention was not riveted by the dishes placed before them may have noticed that the dining room was ornamented with arrangements of gearshift and radio knobs, horn buttons, window winders and distributor housings. These too were soya products – plastics derived from soya protein.[46] The Model T had incorporated coil cases made from a plastic based on wheat gluten as early as 1915.[47] Rayon had recently been developed from a wood base.

Ford's enthusiasm for the soya bean reached its peak when he lent his support to 'Chemurgy', a populist response to the Depression which he could almost have devised himself, so closely did it mirror his aspirations. Chemurgy taught that modern science could solve the problems both of farmers and of industry. Farmers were going out of business, obliged to plough back unsaleable crops or slaughter and burn surplus livestock, while industry threw men out of work who then went hungry. If farmers could produce crops which could become either fuel or the raw materials of industry, both stood to gain.[48] Ford built a soya processing plant at River Rouge. By 1937, 2lb of every Ford car was made from soya products. Ford's chief soya bean research engineer even developed a trunk lid from soya plastic, the strength of which Ford graphically demonstrated to the press by smashing it with an axe; and had he not turned the sharp edge of the axe towards the trunk lid, it may not have split in two. In fact, most plastics in succeeding decades were derived from mineral sources. Today, the concept of the 'renewable resource' has practical, economic and political currency. Ford's soya bean plastics may yet prove more than just another in a long catalogue of the idiosyncratic millionaire's cul-de-sac dreams.

Whatever else was artificial about Greenfield Village, the children were

real enough. The one-room schoolhouse had grown from one grade in 1929 to twelve by the early forties, and had spilt over into other buildings. Each morning the pupils assembled and sang in the white-painted church on the village green. With increasing regularity the architect of the illusion in which they were participating took to sitting at the back and listening to their young voices. The Martha–Mary Church was named in memory of Clara's mother and his own. Spotting a resemblance between Clara's niece, Dorothy Richardson, and his mother, Mary Litogot Ford, Henry decided to make and personally direct a film of his most vivid early family memories. On Ford's instructions, Dorothy was dressed in clothes resembling those worn by his dead mother. Ford had an abiding belief in reincarnation; for him Dorothy *was* his mother reincarnated. Accordingly, he taught her to drive, so that she could experience something of the device which had made her son rich, successful and world famous.

The approval of a parent, family life and the love of children were fitting, if not always happy preoccupations for Henry Ford in old age. He had at least one son of his own.[49] Edsel Ford was born in 1893 and had been president of the Ford Motor Company since his father's resignation in 1918. In reality, the resignation had more to do with Ford's battle with stockholders than a desire to relinquish control.[50] He always disliked giving his collaborators job titles which defined their roles. It soon became apparent that while his father was alive, Edsel was president in title only. When, for example, he planned and began construction on a range of coke ovens for the Rouge plant, he thought he had his father's approval. Henry watched their construction; then, days after they were completed, he had them torn down.[51] These and countless lesser and greater cruelties came from a man who both loved and misunderstood his son. In his fictionalised account of his own youth, Ford had stood up to his father when the time came to assert his independence. Edsel never did. He was amiable, well liked by his colleagues and somewhat sensitive – quite unlike his boisterous, larger than life father. Ford thought he lacked guts and, out of love for him, would thwart and provoke his son to toughen him up; Edsel, out of love for his father, capitulated at every turn.

Sprightly in old age and fond of demonstrating his fitness to a gawping press, Ford was forced gradually to acknowledge that his involvement with automobiles was increasingly a historical rather than contemporary matter. The artist Irving Bacon, from whom he commissioned a series of

Reconciling agriculture and industry. Ford, in a suitably picturesque arrangement of corn sheaves, wears a suit made of soya bean fibre; similarly (opposite) to demonstrate the virtues of a trunk lid made of soya protein, Henry Ford smashes it with an axe before the press. It had been intended he should use the blunt, rather than the sharp edge. The lid shattered.

paintings to commemorate his life, noticed that the space Ford had given him for a studio in the engineering laboratory was gradually being repossessed for its original purpose. Ford's control of the company to which he had brought nothing but his talent in 1903 loosened in stages.[52] None of these was without pain. The brutal battle he waged by proxy through Harry Bennett against organised labour at the Ford plants finally came to a head in 1941. Following a strike, Edsel succeeded, for once, in changing his father's mind. Ford agreed to negotiate with the unions. They had secured court decisions in their favour and with America gearing up for war – and war contracts – the Ford Motor Company could ill afford labour relations out of sympathy with the national mood under President Roosevelt. Clara Ford, sensible not only of the bloodshed which had accompanied Ford's dispute with the unions, but painfully aware of the

toll it was taking on their son's health, issued a plain ultimatum: if he did not agree to the unions' demands, she would leave him.[53]

As in the First World War, Ford's attitude towards the Second displayed the same 'common-sense' reluctance, the same readiness to pronounce and advise and the same moral and intellectual elasticity when hostilities eventually began. It was the massive Willow Run plant – 'the most enormous room in the history of man'[54] – which captured the public imagination. The war against the Japanese had not been going well. This spectacular demonstration of American 'know-how', a plant which promised to deliver one finished B-24 bomber every hour of every day, seemed to be an eagerly awaited sign that America was fighting back. Though everyone knew Edsel Ford and Charles Sorensen were actually responsible for its creation, there was still a walk-on part for an American folk hero. The white-haired figure obliged.

He was less in evidence when things started to go wrong. With Ford nearing eighty and Sorensen in failing health, it was Edsel who took the

Father and son in the Plympton House, Greenfield Village, 1941. Henry and Edsel had a complex, loving, but unhappy relationship with one another. In this image, both stare reflectively at an electric light bulb burning in the hearth where the fire would have been.

brunt of public outrage when it emerged that, far from producing a plane an hour, the plant was barely limping along. 'The March of Time' newsreel warned American cinema-goers, 'mis-management and lack of morale in Detroit . . . is slowing U.S. war production to the danger point.'[55] Public symbol became public scandal.

Henry Ford spent more and more time at Greenfield Village. A photograph taken in 1941 shows him in the Plympton House, sitting with Edsel on an old wooden settle, bathed in the glow of an open fire into which both are staring. Edsel looks pensive. Close inspection of the photograph seems to suggest there was no real fire in the grate, only a discreet electric light bulb. The actual cause of Edsel's death in 1943 seems to have been cancer of the liver with complications. The extent to which other, less directly medical factors may or may not have played a role remained a constant source of speculation, not least to the late president's father.[56]

Henry Ford died on 7 April 1947.

Notes

1 Robert Lacey, *Ford the men and the machine* (London, 1986), pp. 237–49.
2 Quoted in *Greenfield Village and the Henry Ford Museum*, by the Henry Ford Museum staff (New York, 1972), p. 10.
3 Lacey, *Ford*, p. 239.
4 There are, of course, exceptions, such as the Kennedys. Yet even they have not been above posing in front of humble Irish dwellings by way of meeting the 'humble origins' quotient.
5 Lacey, *Ford*, p. 12.
6 Lacey, *Ford*, pp. 10–11.
7 Allan L. Benson, *The New Henry Ford* (New York, 1923), p. 34, quoted by Lacey in *Ford*, pp. 15–16.
8 The firm was actually called the Detroit Dry Dock Company according to Lacey, *Ford*, p. 16, n. 40.
9 Quoted by Lacey, *Ford*, p. 15.
10 Lacey, *Ford*, pp. 15–17.
11 Lacey, *Ford*, pp. 32–5.
12 Lacey, *Ford*, pp. 34–5.
13 Lacey, *Ford*, pp. 36–7.
14 Quoted by Lacey, *Ford*, p. 78.
15 Quoted by Lacey, *Ford*, p. 87.
16 Lacey, *Ford*, p. 90.
17 David A. Hounshell, *From the American System to Mass Production, 1800–1932* (Baltimore and London, 1984), p. 224.
18 In Hounshell's opinion, the series of articles written by Fred Colvin in the *American Machinist* in 1913 are among the most perceptive from a technical perspective.
19 Quoted by David L. Lewis, *The Public Image of Henry Ford, An American Folk Hero and His Company* (Detroit, 1976), p. 70.

20 Lacey, *Ford*, pp. 116–17.
21 A figure from a hostile article which appeared in the *New York Daily People*; cited by David E. Nye, *Henry Ford, 'Ignorant Idealist'* (Port Washington, New York and London, 1979), p. 14.
22 Nye, *Henry Ford*, p. 13.
23 Nye, *Henry Ford*, p. 13.
24 The *New York Daily People* is quoted by Nye, *Henry Ford*, p. 14; all the other papers quoted here as well as the remark by the general manager of the Erie City Iron Works were quoted by Lewis, *The Public Image*, pp. 71–2.
25 Lewis, *The Public Image*, p. 74.
26 Quoted by Nye, *Henry Ford*, p. 15.
27 Quoted by Lacey, *Ford*, p. 139.
28 Quoted by Nye, *Henry Ford*, p. 16.
29 Quoted by Lacey, *Ford*, p. 145.
30 Nye, *Henry Ford*, p. 16; according to Lewis, *The Public Image*, p. 96, Ford's war profits, though comparatively modest, were never returned to the US Treasury, although the myth that they were was sustained for decades afterwards by the Ford publicity machine, among others.
31 Quoted by Lacey, *Ford*, p. 198.
32 *The Nation*, quoted by Nye, *Henry Ford*, p. 17.
33 Quoted by Nye, *Henry Ford*, p. 18.
34 Lacey, *Ford*, pp. 210–11.
35 Lacey, *Ford*, pp. 27–9.
36 Lacey, *Ford*, p. 207.
37 Quoted by Lacey, *Ford*, p. 218.
38 Quoted by Lacey, *Ford*, p. 219.
39 Lacey, *Ford*, pp. 218–19.
40 Quoted by Lacey, *Ford*, p. 309.
41 Lacey, *Ford*, pp. 342–5; Nye, *Henry Ford*, pp. 44–5.
42 Lacey, *Ford*, pp. 309–12.
43 Nye, *Henry Ford*, p. 49.
44 E. B. White, *Farewell My Lovely*; quoted by Nye, *Henry Ford*, p. 47.
45 Nye, *Henry Ford*, p. 65.
46 Lacey, *Ford*, pp. 227–8.
47 Lacey, *Ford*, p. 232.
48 Lacey, *Ford*, pp. 231–3.
49 It was speculated, but never proven, that John Dahlinger, born in 1923, was Ford's son. For a detailed discussion see Lacey, *Ford*, pp. 183–93.
50 Lacey, *Ford*, pp. 165–79.
51 Lacey, *Ford*, p. 263.
52 Lacey, *Ford*, pp. 442–4.
53 Lacey, *Ford*, pp. 376–8.
54 Quoted by Lacey, *Ford*, p. 391.
55 Quoted by Lacey, *Ford*, pp. 393.
56 Lacey, *Ford*, pp. 394–8.

2 Building the machine

In 1904, before the Model T was introduced, annual production of the 'Merry Oldsmobile', a light runabout, had soared to 4,000 vehicles.[1] Oldsmobile ran into financial difficulties and the car was apt to shake itself to pieces on the largely unmade American roads of that time. The future of the motor industry seemed far from clear. With Cadillac making similar numbers of vehicles, there was 'much scepticism as to whether production on this huge scale could be maintained.'[2] *Horseless Age*, the oldest trade journal of the industry, warned prospective investors against 'promoters' gilded dreams of 5,000 men in a single factory'.[3]

Yet expansion was not contingent on outside investment. The Ford Motor Company – like most of its early rivals – was largely self-financing.[4] What was required was belief that a market existed, a car of sufficient quality, produced in sufficient quantity and at a competitive price. Ford had been convinced by the Model N that there was indeed a demand. The design of the Model T, reminisced Ford in 1922, was deliberately kept simple: 'There were but four constructional units in the car – the power plant, the frame, the front axle and the rear axle.'[5] The engine was more powerful than that used in the Model N and the four-cylinder engine block was made from a single casting instead of two. The transmission was a planetary arrangement which provided one reverse and two forward gears engaged by using foot pedals. Both the flexibility provided by the two large leaf springs (one laid across each axle) and the height of the axles from the ground suited the car to the poor road conditions commonly found throughout the country. Simplicity was combined with strength and lightness, thanks largely to the intensive use of vanadium steel. The car proved reliable and simple to maintain. At $850 for the open touring model – effectively the standard four seater – it was more expensive than the Model N, but competitively priced in terms of the market in 1908. Its external appearance was somewhat utilitarian; that

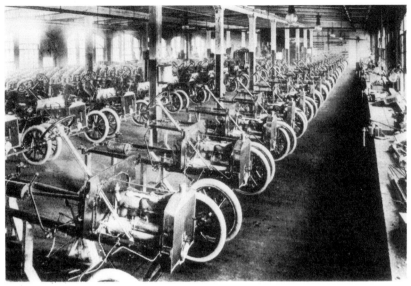

Assembling Model Ns at static workstations, Ford's factory at Piquette Avenue, 1906. As in most car 'manufacturers' at this date, the majority of components were bought from outside contractors. The factory was largely devoted to assembly.

which needed to be covered, was. But this was equally true of most cars on offer in 1908, including many costing more than the latest Ford model. Ford wanted the latest to become the only. Writing, via Crowther, in 1922 he referred to the 'universal car'.

> Therefore in 1909 I announced without any previous warning, that in future we were going to build only one model, that the model was going to be the 'Model T,' and that the chassis was going to be the same for all cars, and I remarked:
>
>> 'Any customer can have a car painted any colour that he wants so long as it is black.'[6]

This is Ford waxing mythical. It is unlikely he ever uttered the famous phrase; and if he really said such a thing in 1909, it seems odd that the Model T remained available in a range of colours until 1914.[7]

The decision to produce only the Model T coincided with the whole-sale moving of the manufacturing plant from the Piquette Avenue factory

to the new and larger premises. Piquette Avenue had always seemed modest compared with the Packard Factory, built in 1905. Ford employed the architect of that building, Albert Kahn, to design one still larger at Highland Park. The task facing Ford's engineers – especially Peter E. Martin, effectively the factory superintendent, and Charles Sorensen, his assistant – was to devise the means by which the Ford Motor Company could keep pace with the ever increasing demand for the Model T. Even with only one basic product, it was a complex problem. They were moving from a factory space of 2.65 acres to one of 32 acres to manufacture a product which contained – including screws, nut and bolts – about 5,000 parts.[8]

In addressing this daunting task, Ford and his engineers were able to draw on a range of manufacturing concepts and techniques, some of which had been evolving for more than a century. To understand both the magnitutude and the limitations of their achievements, some appreciation of these developments is necessary. As noted earlier, Ford's retrospectively compiled checklist for mass production stressed the need for 'power, accuracy, economy, system, continuity and speed'. Following the transformations of industry achieved by means of water and then steam, electrical power was now creating new possibilities. The Highland Park factory used electricity generated by a 3,000-horsepower gas engine, which Ford thought beautiful.[9]

Greater accuracy had been striven for in the century before Highland Park opened in pursuit of the *interchangeability* of parts. This idea, first developed in the second half of the eighteenth century in France by General Jean-Baptiste de Gribeauval, sprang from the rationalist tradition of the Enlightenment. It was argued that economies might accrue – especially in connection with maintenance and repair – if each part of a gun were made so similar in dimensions to the same part in a gun of the same design, that the two parts might be interchangeable. The traditional approach, characterised as the 'European' system in later years, was for skilled craftsmen to 'fit' each piece to its neighbours using files. Thus, while each gun might bear a superficial resemblance to another of the same design, it was, in reality, unique.

A system which reduced reliance on skilled craftsmen was particularly attractive to the United States Ordnance Department. Craft skills in eighteenth- and early nineteenth-century America were in short supply and the United States Army was often obliged to operate in remote, undeveloped areas. Under the Ordnance Department's patronage, interchangeability

was promoted both at its own armouries and at the principal private armouries with which it placed contracts. An earlier legacy of the Enlightenment, the division of labour – where each worker undertook only a part of the manufacturing process rather than the making of (in this case) an entire gun – could further reduce reliance on skilled labour. Gradually, to these ideas was added the belief that machines, rather than hand work, might provide a more appropriate means of achieving the desired uniformity. The development in America of arms manufacture and of the machine tool industry were intimately linked. Increasingly, specialised, single-purpose machinery emerged – echoing the division of labour – as well as 'self-acting' or semi-automatic machine tools. Both furthered the cause of interchangeability.

The idea of interchangeability was an attractive and simple one but, despite regular claims that it was a manufacturing reality, it proved immensely difficult and costly to achieve on a sustained basis. The government-run Springfield armoury did not fully achieve it until 1849 or 1850, while interchangeability on a large scale first emerged at Samuel Colt's Armoury at Hartford, Connecticut between 1849 and 1855.[10] Both were only possible because of half a century of continued investment by the United States government.

Central to the achievement of interchangeability was the development of a 'rational jig, fixture and gauging system'.[11] If parts were to be alike, something more systematic than simply comparing them with one another was required. One 'ideal' gun, destined never to be fired, was constructed with great accuracy. All production guns were to imitate this ideal to within predetermined limits. The 'Platonic' gun was used as a reference point in the design of the whole production process. Jigs and fixtures are devices used to hold metal firmly while the cutting part of a machine tool acts upon it. The accuracy with which they presented each part was critical in the achievement of uniformity. After each production stage, gauges were employed to check how much larger or smaller a part might be before it failed sufficiently to imitate its Platonic ideal.[12]

The early manufacture of sewing machines was often closely linked with the activities of gun and machine tool makers, to the extent that they sometimes shared factories, personnel, manufacturing equipment and the 'armoury' ethos. The most notable exception seems the more paradoxical for being the most successful. From 1867 onwards the Singer Manufacturing Company, which had from the first used 'European' techniques, outstripped their 'American system' rivals, Wheeler & Wilson. Though

not recognised in such terms at the time, their victory demonstrated that armoury practice was not essential for the production of a high-quality product in comparatively large numbers and that sophisticated manufacturing techniques alone could not guarantee high-volume sales, which might depend more on effective marketing strategies. Once rising annual production exceeded half a million sewing machines in the early 1880s, the Singer Manufacturing Company also began the struggle for interchangeability, believing it essential for production which could run into millions. Hounshell shows that the McCormick reaper company began adopting armoury practice at about the same time, thirty years later than had customarily been thought. In both cases, uniformity took years to achieve.

Armoury practice spread to the manufacture of typewriters and bicycles. In the hands of bicycle manufacturers it was brought to new levels of sophistication. However, in the drive for ever greater economies, some manufacturers, particularly those in the Midwest, began substituting metal stampings for components which in the armoury tradition had been castings. Electric welding techniques were also introduced.

Power, accuracy, economy and system had all been developed to high levels; it was in the areas of 'continuity and speed' that the Ford Motor Company transformed contemporary techniques. In identifying the factors which led to the evolution of the assembly line, it is worth remembering that the company began life as an *assembler* of automobiles, long before it became a significant manufacturer. Thus, for many years, the act of assembly was the focus of the 'manufacturing' process. At the Piquette Avenue factory, gangs of perhaps fifteen men would put complete cars together from piles of components, with wooden stands to support the automobile during assembly.[13]

While, as will be shown, Ford cannot be credited with single-handedly 'inventing' mass production, explanations of the technique which rely almost exclusively on technological, economic or cultural factors give insufficient weight to the extent to which Ford's character and beliefs were instrumental in making it a reality. As shown in chapter one, Henry Ford did not like being thought dependent on others. Ford's campaign to oust Alex Malcomson coincided with the plan to concentrate the company's effort on the Model N. The strategy involved setting up the Ford Manufacturing Company to manufacture components for Ford cars, a company in which Malcomson had no part. In addition, the decision

would reduce the Ford Motor Company's dependence on outside contractors. While equipping a separate plant at Bellevue Avenue to make engines and some small components, Ford met Walter P. Flanders. In August 1906, Flanders was made production engineer for both companies; earlier that year, he had persuaded Ford to appoint Max F. Wollering. Both were well versed in the armoury tradition.

Wollering was responsible for introducing a rational jig, fixture and gauging system at the Bellevue Avenue plant. Both men impressed on Ford personnel the need for interchangeability in high-volume production and the economies made possible by single-purpose machines. Flanders wrote a report which served to emphasise the *flow* of materials and organised machine tools and other equipment on the shop floor in sequential arrangements. Components had only to be passed from one piece of equipment to another, without unnecessary travel to and from centrally located batteries of lathes or forges. He also expressed ideas about marketing in his policy document. As Sorensen wrote in his memoirs, Flanders 'created greater awareness that the motor car business is a fusion of three arts – the art of buying materials, the art of production, and the art of selling.'[14]

Long before Flanders and Wollering could school Ford's young team in the minutiae of armoury orthodoxy, the two moved on, following offers from the Wayne Automobile Company. It was through Sorensen that Ford had contact with the metal pressing firm of John R. Keim of Buffalo, New York. Before the first few years' production of the Model T had elapsed, pressings from Keim had become so integral, that Ford first bought the company and then, in 1912, moved its machinery and personnel to Highland Park. In this way, the Midwest tradition of manufacture which emphasised the intensive use of metal stampings instead of castings also became standard practice at Ford. By 1913, interchangeability had been achieved and most of the economies in the manufacture of parts offered by the Ford fusion of current best practice had been secured. Demand was still increasing. There was little more that could be done to speed the manufacture of parts for the Model T. Ford's engineers turned their attention to assembly.

The stages which led to the introduction of moving assembly lines were rapid and complex. As Hounshell remarks, 'the development of the assembly line at Ford was so swift and powerful that it defied accurate, timely documentation'.[15] The example of the magneto flywheel moving assembly line devised by Martin, Sorensen and others may or may not have been the first, but it was certainly among the earliest. Workers

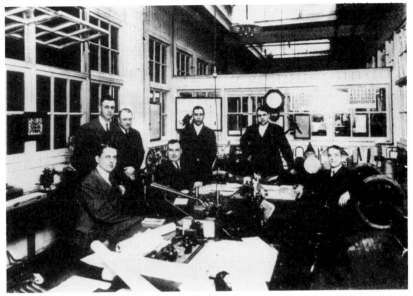

Engineers at the Ford Motor Company, 1913. 'Fordism' – the earlier name by which mass production was known – was not devised by Ford alone, but resulted from the combined efforts of a talented team. These included (seated, left to right): Charles Sorensen, P. E. Martin and C. H. Wills, as well as Clarence Avery, seen here standing directly behind Sorensen.

reporting for duty on 1 April 1913, found that the benches on which they had been accustomed to assemble the flywheel magnetos had been replaced by waist-high rails just wide enough for the flywheel magnetos to slide along. Each worker was told to complete only part of the assembly process – perhaps just the tightening of a nut – before sliding the flywheel magneto to the next worker. The same number of workers now completed a flywheel magneto every thirteen minutes and ten seconds, instead of every twenty minutes. This level of production was not achieved without problems. The workers complained that bending over the rails all day hurt their backs. The rails were raised six or eight inches. Some workers were quick while others worked at a slower pace. The traditional solution to this problem would have been to introduce piece rates, giving the slower workers an incentive to work faster. But this is another occasion where, albeit obliquely, Henry Ford's character precipitated a revolutionary change. Ford disliked piece-rate systems and would not have them anywhere in his factory.

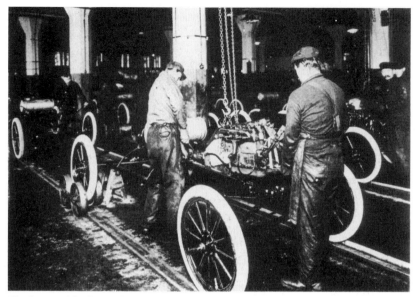

Final assembly line, Highland Park, 1913. Engines are being dropped into place. At this stage, the chassis were being pushed along tracks by hand to each new workstation.

The engineers' solution was to introduce a chain which moved the flywheel magnetos along the rails at a predetermined speed; this had the effect of slowing down those who worked too fast and speeding up the slow ones. The moving assembly line, like the factory itself, is principally an instrument of labour management. Each flywheel magneto now took just five man-minutes to assemble.[16]

Fully fired with the economies this new approach might deliver, experiments in other departments were undertaken in rapid succession. William Klann, together with others, developed an engine assembly line. The transmission assembly was subject to the same transformation until Sorensen and Edsel's former teacher, Clarence W. Avery, set to work on the chassis assembly line. It was this, more than any other, which came to represent the definitive assembly line in the public imagination. Experimentation, refinements and improvements continued in succeeding years, until virtually every process involved in assembly and sub-assembly was completed on a moving line.

As indicated in chapter one, the enthusiasm of Ford's engineers for the assembly line was more than matched by Ford workers' loathing of it.

Final assembly line, Highland Park, 1914. Radiators and wheels slide down chutes to the workstations. The chassis were now being drawn along by chains mounted between the tracks. The tracks themselves were raised on frames to accomodate the chain and make the work more accessible.

Why suffer the indignity, the relentless boredom of tightening that nut over and over again all day, every day, for six days a week at a rhythm dictated by a machine? As long as there were jobs to be had elsewhere, the assembly line was a powerful disincentive to work at Highland Park. Apart from the extra costs, rapid labour turnover was making production planning an uncertain art. By late 1913 the situation had deteriorated to the point where for every 100 men actually needed, the company was obliged to take on 963.[17] The $5 day – which promised Ford workers twice the current going rate for the job – was announced on 5 January 1914. The $5 day recognised that workers are also customers, and that if the market is to thrive high wages are essential. With its introduction, the final piece of Ford's ideal version of mass production fell into place.

'The idea came in a general way from the overhead trolley that the Chicago packers use in dressing beef', wrote Ford airily in 1922.[18] The 'disassembly' of beef carcasses had long been a highly mechanised affair, first in Cincinnati and then Chicago. Hanging from a hook which ran on an overhead rail, each carcass would have a part removed before it was

pushed along to the next workstation, where another part would be cut off. There is no reason to doubt Ford's assertion, but, as Hounshell points out, it is almost certainly only part of the story. Evidence suggests that the notion of *flow* in the handling of materials seems to owe some debt to Oliver Evans' famous automated flour mill of the late eighteenth century as well as their late nineteenth- and early twentieth-century equivalents in the milling and brewing industries. The contemporary manufacture of tin cans – central to the meatpacking industry – embraced special-purpose machinery and moving conveyors. Frederick W. Taylor was a prophet of time and motion study and, in common with the Ford Company, recognised that efficiencies could be achieved by rational analysis of production methods. Yet it appears that 'Taylorism' as outlined in his *Principles of Scientific Management*, published in 1911, had little direct effect at Highland Park. Whereas, under Taylorism, a set task might be analysed to discover the most efficient way in which workers might accomplish it, Fordism looked at production as a whole and raised the more fundamental question as to whether the task needed doing at all. Besides, beyond demanding universal recognition that he was in absolute authority, Henry Ford had a dislike of formal managerial structures.

The effects of these innovations in Detroit at the beginning of this century are still being felt by us around the world today. Some of them are the subject of the balance of this book. The more immediate consequences for the Ford Motor Company were spectacular in terms of reduced production costs, lower prices and an exponential increase in sales. Allowing for unevennesses caused by world war and occasional economic crises, the price of the Model T was consistently driven down still further. The open touring car, which had cost $850 in 1908, could be had for a mere $290 from 2 December 1924 and throughout 1925. At $260, the two-seater runabout was still cheaper. Sales, which in 1911 stood at 39,640, had risen to 182,311 by 1913, the year when assembly lines began to be introduced; by 1917 they had shot up to 740,770 motor cars. By 1921, the Model T accounted for 55.67 per cent of all cars sold in the United States with sales well in excess of one million cars a year in ensuing 'boom' years.[19] Before production was halted in 1927, fifteen million Model Ts had been built.

With profits pouring in and public acclaim as to his sagacity and genius ringing in his ears, Ford set out to create his first ideal world at Highland Park. Whereas later, at Greenfield Village, he tried to mould public

perceptions of American history by assembling a body of heavily 'editorialised' material evidence, at the Ford Motor Company factories he tried directly to mould the lives and perceptions of those who worked on his assembly lines. He tried to manufacture ideal Americans.

His activities should not be seen simply as the personal whims of an industrialist who may or may not have been the richest man in the world. His campaign was not so different from those of his fellow Detroit industrialists who, like him, were white and mostly American-born Protestants. It was, perhaps, more intense. Most of the people these men employed were immigrants from Russia, Poland, Italy, Greece – anywhere where there was poverty and the perception of limited opportunities. Similarly, many black share-croppers from the South made their way to this booming industrial city. Each of these groups – those from Europe had often been peasants – brought with them traditions, festivals and social habits which to the industrialists were unfamiliar, threatening and incompatible with the increasing discipline they demanded of their labour force. If a Pole married, the celebrations might last two or three days. As Steve Babson remarks, 'They resisted straight-jacket discipline, skipped work or came in late, and generally jumped from job to job in the booming auto industry.'[20] Under the auspices of the Urban League, various social and reforming groups were brought together to 'Americanize' Detroit's ethnic populations. The League sought, for example, to 'educate' the 'loud noisy type of Negroes unused to city ways' by publishing books of advice. Babson enumerates: 'don't be late for work; don't wear flashy clothes; don't use loud or vulgar language . . . don't braid the children's hair in certain ways'. English language classes were organised by the 'Americanization Committee' of the Detroit Board of Commerce.

Ford was in sympathy with these activities but, being Ford, devised his own strategies for the 'Americanization' of his own workers. Amidst the hysteria which greeted news of the $5 day, few had noticed that workers did not automatically qualify for this generous rate of remuneration. The establishment of Ford's Sociological Department pre-dated the famous wage increase, but came into its own once the $5 day was introduced. Its first head, John R. Lee explained to an audience in 1916:

> It was clearly foreseen that $5 a day in the hands of some men would work a tremendous handicap along the paths of rectitude and right living and would make of them a menace to society in general and so it was established at [the] start that no man was to receive the money who could not use it advisedly and conservatively.[21]

The purpose of the department was not only to tend to the welfare of Ford workers, but to determine which displayed the desired social characteristics. $5 a day equalled 62.5 cents an hour. Each worker received a minimum of 34 cents an hour; the additional 28.5 cents was viewed as a share of profits, and was only available to married men 'living with and taking good care of their families', single men over twenty-two 'of proven thrifty habits' or single men under twenty-two supporting a relative. If there was a question mark over their status the department would first try to 'strengthen their resolve by kindly suggestion' and if that failed, sack them. Reasons for taking men off the 'Honor Roll' in 1917 included, 'Polish wedding, drunk ... selling real estate ... domestic trouble ... crap game while on duty'.[22] Buying goods on credit could also lead to demotion. The Department would go to workers' homes and discuss ideas from a pamphlet entitled *Helpful Hints and Advice to Employe[e]s*. Was their backyard clean? Did their dining room resemble that shown in the photograph of a profit-sharer or that of a non-profit-sharer? 'Employe[e]s should use plenty of soap and water in the home, and upon their children, bathing frequently. Nothing makes for right living and health so much as cleanliness. Notice that the most advanced people are the cleanest.'[23]

Ford discouraged women from working as a matter of moral principle. Eighty-two were dismissed in 1919 when it was discovered that their husbands were in work.[24] In 1923, he was forthright in his advice to readers of *Ladies' Home Journal*, 'I consider women only a temporary factor in industry ... Their real job in life is to get married, have a home and raise a family. I pay our women well so they can dress attractively and get married.'[25] One advantage, he argued, of the division of labour to the point where each task required little or no skill was that it enabled those with physical disabilities, the 'sub-standard'[26] as he called them, to work as productively as the able-bodied, rather than being an economic burden on society. Similarly, men recovering from injury were supplied with 'black oilcloth covers' for their beds so they might put nuts and bolts together and earn a living.[27]

Employees could turn to the *Ford Guide*, published in 1917, for wisdom. It advised, 'Yellow races ... have been called half civilized, because they have not got ahead quite as well as white people.' Ford was always ready to be photographed with black workers, of whom there were far more than at other plants in Detroit. If they had an interest in their own history, the *Guide* obliged them with: 'Black people came from Africa

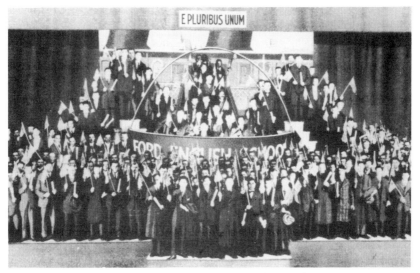

In 1914, 70 per cent of Ford's workforce was made up of twenty-two different nationalities. By setting and enforcing standards of 'right living', and teaching English, Ford sought to 'Americanize' them. In this pageant workers descended into the Ford English School melting pot in their national dress, only to re-emerge in American clothes waving the stars and stripes. English was the language of orders.

where they lived like other animals in the jungle. White men brought them to America and made them civilized.'[28]

At Highland Park some twenty-two languages might be spoken and safety notices had to be printed in at least eight of them. The acquisition of English may have been of genuine benefit to many recent immigrants; the fact that it was taught at Ford by unpaid, volunteer fellow workers suggests it was seen in that light. But Lee makes it clear that this was of secondary importance. English was the language in which orders were issued.[29] Using Dr Roberts' 'Dramatic Method', students were concerned not only with niceties of tense and mood, but with correct methods of brushing their teeth, how to hold a knife and fork. Lee's successor, the Reverend Samuel S. Marquis, described the pageant in which English language students took part 'in the largest hall in the city'. The immigrant experience was reduced to bizarre parody:

> On the stage was represented an immigrant ship. In front of it was a huge melting pot. Down the gang plank came members of the class dressed in their

national garbs . . . [they descended] into the Ford melting pot and disappeared. Then the teachers began to stir the contents of the pot with long ladles. Presently the pot began to boil over and out came men dressed in their best American clothes and waving American flags.[30]

What Ford, the benefactor, tried to achieve through the Sociological Department and Ford English classes paralleled, in part, the evil many critics of mass production feared would happen anyway: that assembly line workers would lose their identities. 'I have been told by parlour experts that repetitive labour is soul- as well as body-destroying', confided Ford in *My Life and Work*:[31]

> Repetitive labour – the doing of one thing over and over again and always in the same way – is a terrifying prospect to a certain turn of mind. It is terrifying to me. I could not possibly do the same thing day in and day out, but to other minds, perhaps I might say to the majority of minds, repetitive operations hold no terrors. In fact, to some types of mind thought is absolutely appalling . . . The average worker, I am sorry to say, wants a job in which he does not have to put forth much physical exertion – above all, he wants a job in which he does not have to think.[32]

He allowed that the workers' physical environment affected their behaviour. If workers sharing in profits were expected to have clean backyards and bathe a lot, this was no more than an extension of the conditions he enforced at the work-place. Enthusing over the River Rouge plant, he wrote, 'Something like seven hundred men are detailed exclusively to keep the shops clean, the windows washed, and all of the paint fresh. The dark corners which invite expectoration are painted white. One cannot have morale without cleanliness.' As far as Ford was concerned, 'The wages settle nine tenths of the mental problems and construction gets rid of the others.'[33]

Some evidence suggested otherwise. Less than two weeks after the $5 day was introduced, the wife of an assembly line worker wrote to Henry Ford: 'The chain system you have is a *slave driver! My God!*, Mr. Ford. My husband has come home & thrown himself down & won't eat his supper – so done out! Can't it be remedied? . . . That five-dollar day scheme is a blessing – a bigger one than you know but *oh* how they earn it.'[34] Charles A. Madison relates in 'My Seven Years of Automotive Servitude' how, shortly after the announcement of the $5 day, he had left his job at Dodge Brothers for work at Ford, not realising he would only

be considered for the $5 after six months. He lasted a week. Working at Ford was, he wrote, 'a form of hell on earth that turns men into driven robots.'[35] Workers developed strategies for dealing with the assembly line. Some would do their own and a neighbour's task for a few minutes so that an illicit cigarette might be enjoyed on the roof. The 'Ford Whisper' became the means by which they evaded the rule of silence at work enforced by supervisors. The 'toilet loafer' became a breed of worker the management tried to weed out.[36]

With the economic difficulties of the years immediately following the First World War, the activities of the Sociological Department were significantly wound down until they resembled those of any other personnel department. Marquis was sacked in 1921. Gradually, the ageing Ford's labour relations became the province of the Service Department, the strong-arm tactics of Harry Bennett, his gangland cronies and the internal espionage for which he was responsible. In 1932, Walter Cunningham published a pamphlet entitled, *J8*. J8 was his work number at Ford. He chose the title because, 'it signified "lost identity" '. He described the tedium of the work, the short and rigidly enforced rest and eating periods as well as the constant surveillance of the Ford Service Department. 'In exchange for the identity numbers and our wages we gave to the Ford Motor Company not only eight hours labor, but we also surrendered our individuality, and inventive genius, if any.'[37]

For Henry Ford, the Model T was far more than just a car or even a product. If Ford enjoyed the role of philosopher whenever journalists gave him the opportunity, the Model T became for him, as well as for much of his admiring public, a physical embodiment of a good deal of that philosophy. An 'honest', no-nonsense car, strong, reliable, designed according to a rational programme of experimentation. 'We did not attempt to go into real production until we had a real product. That product has not been essentially changed.'[38] Its design did not, could not change, because its changelessness was evidence of the universality of the truths to which it bore witness. 'We want to construct some kind of machine that will last forever . . . We want a man who buys one of our products never to have to buy another. We never make an improvement which renders any previous model obsolete.'[39] The more people bought it and the longer its success endured, the more Ford's publicly pronounced beliefs were vindicated. At home, the Model T had made him arguably America's greatest hero and carried him to the threshold of the White House;

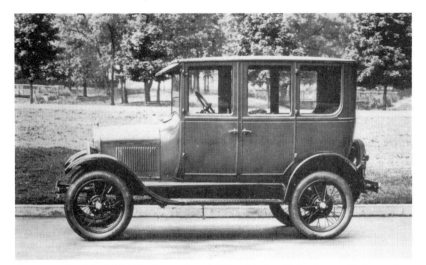

Compare this Model T Fordor sedan, 1927 with fig. 6. In the mythology, the Model T was unchanging – apart from practical improvements related to use or manufacture – and you could 'have it in any colour, as long as it was black'. In practice, Ford was not above introducing stylistic changes throughout its life, increasingly so as sales fell in the mid 1920s. Colour was reintroduced in 1926.

while in the world at large, his name was celebrated from Moscow to Munich. The policy of improving production efficiency and thereby reducing prices had paid off spectacularly for more than a decade. When he collaborated on *My Life and Work*, Ford did not doubt it would do so again. The national economy was well on the way to recovery and, following a period of war work, the River Rouge plant, larger and more advanced than Highland Park, was given over to production of Model Ts. With its own foundries for the smelting of iron, it was a dramatic display of Ford's desire for 'vertical integration': raw materials in one end and cars out the other, and by implication less dependence on outside suppliers. The Ford idea did not change; its expression just grew in grandiloquence.

There were appreciable gaps between reality and myth. The design of the Model T, for example, was subject to fairly constant alteration. Ford acknowledged, 'The few changes that have been made in the car have been in the direction of convenience in use or where we found that a change in design might give added strength.'[40] He contrasts this relative

changelessness with the ceaseless experimentation in production methods and consequent cuts in cost. Nonetheless, there remains a whole catalogue of modifications which the factors cited by Ford cannot wholly explain. Most notably, the car's appearance was subject to a number of modifications which seem to indicate some concern for aesthetics and style. The body became progressively less angular in 1915 and 1917; in 1923, the whole car was lowered and the body made still more curvaceous. These features figured in the new closed-bodied and achingly, punningly named Tudor and Fordor sedans.[41] The 'styling' changes suggest there was at least a tacit appreciation that – even at the cheapest end of the market – some customer responses to design had little or nothing to do with comfort, convenience or price. Ford revelled in the cavalier (or perhaps, puritan) attitude towards customers' desires expressed in the 'any colour you want, as long as it's black' strategy. In his avuncular mode, he assured readers of *My Life and Work*:

> Now as to saturation. We are continually asked: 'When will you get to the point of overproduction? When will there be more cars than people to use them?' . . . nothing could be more splendid than a world in which everybody has all that he wants . . . We do not have to bother about overproduction for some years to come, provided the prices are right.[42]

The sales figures for 1923 must have seemed reassuring; those for the ensuing years became progressively less so. Ford dealers started to grumble about the car they were trying to sell.[43] By 1926, the changeless, universal car suddenly began metamorphosing at an alarming rate. Apart from changes beneath the surface, the chassis was lowered to make the car appear less top-heavy; the radiator shell – already reshaped in 1917 – was given a flashier, nickel-plated finish; and, most significantly of all, after twelve years, colour options were reintroduced.

The market of the mid twenties was not the market of 1908. When Ford launched the Model T there had been a vast, untapped – unidentified, indeed – market of first-time buyers. In 1910, perhaps only 458,000 of the 18,000,000 families in America owned cars. The Model T transformed this. By 1920, when Ford was making its four millionth Model T, the number of families in America had increased to about 21,000,000, of whom perhaps 8,225,000 – more than a third – owned cars. By 1926 a staggering 19,000,000 of 23,400,000 families owned cars. In the American *Motor* magazine in May, the journalist James Dalton described the 'perfectly obvious' reasons why sales of the Model T were in decline:

Mechanically it is virtually the same as it was seventeen years ago. There is little criticism of its quality or value [for money]. But other automobiles which have more nearly kept pace with changing mechanical trends are not much higher in price. Furthermore, there is an unlimited supply of good used cars which sold originally for much more than the Ford but which now can be bought for no more and often for less than the price of the Ford.[44]

Other manufacturers offered liberal credit terms which enabled 'almost everyone with a steady income to buy a higher priced car than a Ford.' The Ford Motor Company did not offer credit terms because Henry Ford thought the practice immoral. In 1921, only five years earlier, there had been only three four- or five-seat models on offer at less than $1,000; at the beginning of 1926, there were twenty-seven. Motorists had come to prefer the all-weather protection of an enclosed body; by 1926, 75 per cent of Model Ts sold were sedans. But because these were more expensive than the open tourer their prices had come closer to the more expensive competition. Relatively, that competition had grown cheaper.[45]

Even the Model T 'folklore' was becoming a liability: 'The Ford has been for years the butt of countless printed or spoken jests. There was a time when these jibes were held to be good advertising but their cumulative effect has not been favorable to the Ford business. They have driven a very large number of prospect[ive buyer]s to other cars.' Ford was still trying to compete in terms of price when – in general – Americans were 'more plentifully supplied with money than at any time during their history'.[46] With the novelty of owning a car taken for granted, buyers – especially second-time buyers – were looking for something more than mere transport. They wanted motor cars which expressed status, or whose design suggested speed, movement, stylishness or excitement; and this the egalitarian, avowedly utilitarian, ubiquitous Tin Lizzie – however it was tricked out – was increasingly ill equipped to do. The turn around in the car's fortunes – plummeting from more than half the market in 1923 to less than a third in 1926 – was rapid. The introduction of a five-day week was publicised as yet another Ford innovation in labour relations; in reality it was short-time working, as the company tried to produce fewer cars and struggled to sell the accumulating thousands of vehicles slipping efficiently off the production lines.

In public, at least, Ford remained bullish. Interviewed in December 1926, he said:

The Ford car is a tried and proved product that requires no tinkering. It has met all the conditions of transportation the world over ... The Ford car will continue to be made in the same way. We have no intention of offering a new car at the coming automobile shows. Changes of style from time to time are merely evolution. Our colored bodies seem to have found favor. But we do not intend to make a 'six' an 'eight' or anything else outside our regular products. It is true that we have experimented with such cars, as we experiment with many things. They keep our engineers busy – prevent them tinkering too much with the Ford car.[47]

In fact, Ford had already instructed his engineers to begin work on a new model 'for the market' some four months earlier. The earliest surviving drawing of the new Model A, as it became known, dates from about the time Ford gave the interview quoted above.[48] Sales figures for the first three months of 1927 seemed to indicate a market share slipping to one quarter of the whole. On 25 May 1927, it was announced that production of the Model T would cease and Ford would be placing an entirely new model on the market.

The Ford Motor Company's principal rival was General Motors – most directly, its Chevrolet Division. As noted above, awareness at Ford that 'the motor car business is a fusion of three arts – the art of buying materials, the art of production, and the art of selling'[49] existed before the Model T was even put into production. Yet in practice, Ford had focused on the first two, while the third relied – too much, perhaps – on the spectacular news stories generated around the car, its ever quoteworthy creator and his belief that lower prices would always equate with increased sales. At General Motors an alternative and more durable strategy was evolving. Credit for organising the company and making it the most successful in America must principally go to its president, Alfred P. Sloan Jr. He gradually developed policies which enabled General Motors thoroughly to exploit Ford's vulnerabilities. Until the mid twenties, these did not really include price. The Model T was formidably cheap. But General Motors showed a readiness to incorporate such technical advances as electric starters into the design of its cars for the convenience of its customers. It did not see moral objections to customers buying their products on credit and made arrangements for them to do so. Customers were encouraged to offer their old cars in part exchange at favourable terms; the cars were then sold on, ensuring a plentiful supply of second-hand alternatives to a new Model T.

Colour on car bodies had become the preserve of those who could afford *not* to buy a Model T. In 1923, after a programme of research, General Motors introduced Duco, a range of quick-drying coloured lacquers. With more and more closed-bodied cars being sold, the colour of the paint work had an ever greater impact. Appearance was a particular consideration with the Model T's main rival, the Chevrolet. A deliberate policy was adopted to modernise its appearance 'so as to remove the inevitable stigma which rests on low priced articles that show it.'[50] More importantly, instead of just one chassis in a range of bodies, General Motors offered a range of different makes, each with an identity aimed at different sections of the market, from Chevrolet at the bottom to Cadillac at the top, with Pontiac, Oakland and Buick in between. The marketing policy was famously summed up in Sloan's phrase, 'a car for every purse and every purpose.'[51]

Sloan at General Motors made sure that changes in design were planned for, indeed that change was assumed as the norm. Ford's autocratic management style was responsible for General Motors, rather than the Ford Motor Company, benefiting from the talents of production engineer William S. Knudsen. Tired of having his decisions overridden, Knudsen left Ford in 1921 and, about a year later, joined General Motors where he was soon made responsible for production at Chevrolet. He did not attempt to reproduce mass production as Ford had created it. His alternative was 'flexible mass production'. In some ways his system built on earlier carmaking practices, where components were bought in from outside contractors and then assembled, in contrast to the extreme vertical integration at Ford. Motors and axles were made at Flint, Michigan, while transmissions were made at Toledo, Ohio. Thousands of other components were bought in from contractors and the complete cars assembled at four plants dotted round the country. It was this set-up which Knudsen re-organised and rationalised, while retaining its decentralised character. Assembly plants were equipped with moving assembly lines as at Ford, but the use of contractors for the parts made it possible to shop around, to change suppliers and when change was required, to buy a new component without having to bear the whole or the immediate burden of capital investment in new plant. Machine tools at Chevrolet were not the single-purpose type used at Ford – where it was presupposed the Model T would be made for ever – but very sturdily built general purpose machines whose function could be changed as the Chevrolet car changed.[52]

'While the bringing out of yearly models results in many disadvantages

General Motors model production line, Century of Progress Exhibition, Chicago, 1933–34. GM's flexible mass-production techniques, devised, in part, by disaffected Ford personnel, sought to avoid the dangers of inflexibility in the face of changing market demands. Change was not only planned for but encouraged.

and, for that reason we are all against yearly models. I just don't see what can be done about it,' complained Sloan in July 1925.[53] From 1924 onwards, each new year had produced a new model Chevrolet. Annual model changes were introduced to other General Motor divisions and gradually, by the mid thirties, it became the norm for the whole industry, including Ford. By making each model look different every year, technical improvements on last year's model were given dramatic expression. This captured public attention in a way that Ford's evolutionary, irregular, surreptitious approach could not. Of course, changes in appearance might herald negligible or even non-existent technical improvements. Even so, everyone could tell at a glance how old a car might be. The car owner was pressed to trade in the new for the newer. In a market saturated with Model Ts, General Motors sought not merely to provide transport, but to cater for and, of course, trade on the dreams of drivers. Harley Earl, experienced in the design of custom-made bodies for the new, brash stars of the dream factories of Hollywood, was put in charge of a new department, 'Art and Color' in 1927 – the same year that the Chevrolet sold more than a million and that the Model T finally bit the dust.

Finally, whereas Ford revelled in the somewhat anarchic absence of managerial structure – as he explained in the chapter 'Men and Machines' in *My Life and Work*[54] – believing he could boost his power over subordinates by keeping them insecure, Sloan gave General Motors a rational management structure with logical chains of command. To the extent that almost every characteristic of General Motors was a reaction to and often against that which Ford had evolved and embodied the talents of many individuals unable to accommodate Ford's temperament, General Motors may be seen as one of Henry Ford's most enduring and unlooked-for legacies.

'I am glad that business even now is so brisk that it will not necessitate a complete shutdown,' Ford told the *New York Times* in May, 1927, the day after the new Model was announced. 'Only a comparatively few men will be out at a time while their departments are being tooled up for the new product ... The layoff will be brief because we need the men and have no time to waste.'[55] But Ford and his engineers had not designed a completely new model for production for nearly twenty years; they had never designed one which it was intended to mass-produce from the first, nor had they designed from scratch a new production line. The dramatic collapse of the market for the Model T meant that the process was being undertaken to a timetable not of their choosing. Public speculation about

Henry and Edsel Ford in 1927 at the first public showing of the much speculated on and much delayed Model A. Its handsome, if conservative appearance was evidence that Ford now recognised competition could no longer be conducted exclusively in terms of lower prices. By the early 1930s Ford had adopted the annual model change, long exploited by his rivals, General Motors.

the new model was intense and usually wrong. In the event, there was a total shutdown. The design of the Model A was not completed until mid October 1927, and production began in earnest about a month later. The car was not publicly launched until December – six months after its imminent arrival had been confidently announced.

What had gone wrong? A catalogue of reasons could be cited, including Ford's sudden insistence that, in the cause of quality, metal stampings should be replaced with machined castings – a policy not thrown into reverse until much time and money had been wasted. There were other design problems. Ford's anarchic management structure cannot have been significantly strengthened by Sorensen's decision to 'purge' many highly experienced production engineers. But these difficulties pale beside the fundamental problem: mass production as Ford had conceived it was geared to the production of one single product. To begin the production

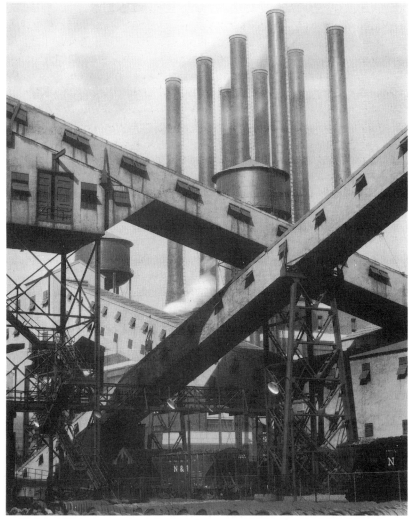

The Ford River Rouge factory as an icon of dynamic modernity. Ironically, Charles Scheeler's famous images were taken during the calamitous shutdown in 1927, as the Model A replaced the Model T.

of another, a vast quantity of dedicated equipment had to be scrapped and replaced. This was not only expensive – some $18,000,000[56] on machine tools, gauges, jigs and fixtures alone in this case – but posed enormous procurement problems because of the scale of the operation. The final cost of the change-over, including lost profits, was put by the Ford Motor Company's official biographers at $250,000,000.[57] As a strategy for addressing a once only, untapped market of first-time buyers, for whom the mere possession of a motor car was an exciting prospect, mass production – as Ford defined and built it – was a dazzling, revolutionary success. As a strategy for addressing a market where buyers accustomed to personal motorised transport wanted variety as well as a sensation at least of constant innovation, it was a catastrophe.

Notes

1 Ralph C. Epstein, *The Automobile Industry, its economic and commercial development* (Chicago, New York and London, 1928; repr. New York, 1972), p. 37.
2 Epstein, *The Automobile Industry*, p. 37.
3 Quoted by Epstein, *The Automobile Industry*, p. 38.
4 Epstein, *The Automobile Industry*, p. 224.
5 Henry Ford, *My Life and Work* (London, 1922), quoted by Alfred D. Chandler Jr. (ed.), *Giant Enterprise, Ford, General Motors and the Automobile Industry, Sources and Readings* (New York, 1964; repr. New York, 1980), p. 36.
6 Henry Ford, *My Life and Work*, quoted by Chandler, *Giant Enterprise*, p. 37.
7 David A. Hounshell, *From the American System to mass production, 1800–1932* (Baltimore and London, 1984), p. 273.
8 Ford, *My Life and Work*, quoted by Chandler, *Giant Enterprise*, p. 38.
9 Hounshell, *From the American System*, p. 228; Robert Lacey, *Ford, the men and the machine* (London, 1986), p. 260.
10 Hounshell, *From the American System*, pp. 45–50.
11 Hounshell, *From the American System*, p. 6.
12 As late as 1886, The Singer Manufacturing Company at Elizabethport, NJ, were using absolute, rather than 'go-no-go' gauges; Hounshell, *From the American System*, pp. 120–21.
13 Hounshell, *From the American System*, p. 220.
14 Quoted by Hounshell, *From the American System*, p. 222.
15 Hounshell, *From the American System*, p. 246.
16 Hounshell, *From the American System*, p. 248.
17 These figures were calculated by Keith Sward from information given by Ford on pp. 129–30 of *My Life and Work*. They appear in Sward's *The Legend of Henry Ford*, p. 49, and are quoted by Hounshell, *From the American System*, p. 257.
18 Ford, *My Life and Work*, p. 81.
19 The prices come from a table given in United States Board of Tax Appeals, vol. 11, p. 1116; reprinted in Chandler, *Giant Enterprise*, p. 33; other statistics from the

Federal Trade Commission, *Report on the Motor Vehicle Industry* (Washington, 1939), p. 29; reprinted in Chandler, *Giant Enterprise*, p. 3.

20 Steve Babson, with Ron Alpern, Dave Elsila, and John Revitte, *Working Detroit, The Making of a Union Town* (Detroit, 1986), p. 34.

21 From a speech by John R. Lee, published as 'The So-Called Profit Sharing System in the Ford Plant', *Annals*, American Academy of Political and Social Science, 65 (May 1916); pp. 299–305 and 308 reproduced in Chandler, *Giant Enterprise*, pp. 189–94.

22 Quoted by Babson *et al.*, *Working Detroit*, p. 35.

23 *Helpful Hints and Advice to Employe[e]s*, quoted by Lacey, *Ford*, p. 125.

24 Ford, *My Life and Work*, p. 111.

25 Elizabeth Breuer, 'Henry Ford and the Believer', *Ladies' Home Journal* (Sept. 1923); quoted by Lacey, *Ford*, p. 126.

26 Ford, *My Life and Work*, p. 110; the benefits of charity, in the form of the Ford Foundation set up in 1936, only became apparent when they coincided with the objectives of tax avoidance.

27 Ford, *My Life and Work*, p. 110.

28 *Ford Guide* (Detroit, 1917), quoted by Babson *et al.*, *Working Detroit*, p. 35.

29 Lee, reproduced in Chandler, *Giant Enterprise*, p. 193.

30 Samuel Marquis, 1916, quoted by Babson *et al.*, *Working Detroit*, p. 35.

31 Ford, *My Life and Work*, p. 105.

32 Ford, *My Life and Work*, p. 103.

33 Ford, *My Life and Work*, pp. 114–15.

34 Ford Archives, Acc. 1 Fair Lane Papers, IV, Ford Mototor Company, 'Personnel Complaints', Box 120; quoted by Hounshell, *From the American System*, p. 259.

35 Charles A. Madison, 'My Seven Years of Automotive Servitude', *Michigan Quarterly Review*, 19/4 and 20/1 (double issue, Autumn 1980/ Winter 1981); quoted by Lacey, *Ford*, p. 128.

36 Babson *et al.*, *Working Detroit*, pp. 32–3; Lacey, *Ford*, p. 350.

37 Walter Cunningham, *J8: A Chronicle of the Neglected Truth about Henry Ford and the Ford Motor Company*; quoted by Nye, *Henry Ford*, p. 43.

38 Ford, *My Life and Work*, p. 17.

39 Ford, *My Life and Work*, pp. 149.

40 Ford, *My Life and Work*, p. 17.

41 Hounshell, *From the American System*, p. 274; sedan Model Ts were first introduced in 1915.

42 Ford, *My Life and Work*, p. 154.

43 James Dalton, 'What Will Ford Do Next?', *Motor* (May, 1926), pp. 30–1, 84; reprinted in Chandler, *Giant Enterprise*, pp. 104–11.

44 Dalton, in Chandler, *Giant Enterprise*, pp. 108–9.

45 Dalton gives the prices for sedans in 1926 as follows: Ford, $565; Overland Four, $595; Chevrolet, $735; Dodge, $895; Chrysler (Maxwell) $995.

46 *Motor* (Dec. 1925); quoted by Dalton, in Chandler, *Giant Enterprise*, pp. 105–6.

47 Henry Ford quoted after interview with James C. Young in his article, 'Ford to Fight It out with His Old Car', *New York Times*, 26 Dec., 1926, section 8, p. 1; quoted by Hounshell, *From the American System*, pp. 276–7.

48 Hounshell, *From the American System*, p. 279.

49 Quoted by Hounshell, *From the American System*, p. 222.

50 William S. Knudsen, ' "For Economical Transportation"; How the Chevrolet Motor

Company Applies Its Own Slogan to Production', *Industrial Management*, 76 (Aug. 1927), pp. 65–8; quoted by Hounshell, *From the American System*, p. 265.

51 *Annual Report of General Motors Corporation for 1925*, 24 Feb. 1926, p. 7; quoted by Hounshell, *From the American System*, p. 278.

52 Hounshell, *From the American System*, pp. 264–7.

53 Quoted by Hounshell, *From the American System*, p. 263.

54 Ford, *My Life and Work*, especially pp. 91–6.

55 Ford interviewed in *New York Times*, 26 May 1927, p. 4; quoted by Hounshell, *From the American System*, p. 279.

56 Hounshell, *From the American System*, p. 288; Hounshell notes that *Ford News* 7 of 1 Sept. 1927 puts this figure at $15,000,000 while Fay Leone Faurote in 'Preparing for Ford Production', *American Machinist* 68, (1928), 635–9, suggests it could have been as much as $25,000,000.

57 Allan Nevins and Frank Ernest Hill, *Ford, Expansion and Challenge 1915–1933* (New York, 1957), p. 458.

3 Making motor cars

No manufacturer anywhere in the world was able *exactly* to repeat Henry Ford's extraordinary success with mass production. This is hardly surprising. In the history of commerce there have been few opportunities to exploit such an enormous, untapped and reasonably homogeneous market. Yet mass production – modified to accommodate different markets and labour conditions and, eventually, other product types – was, with varying degrees of success, widely imitated. Despite the debacle of the change-over from the Model T to the Model A, the sheer scale of Ford's achievements was not easily forgotten. To embrace his example was to embrace one of the most celebrated triumphs of the rational and thus the Modern; its power in this respect was such that many manufacturers sought to emulate it almost without question, and often without reason. The reservations of liberal opinion towards mass production concerned manufacturers only when they figured in relations with their workers or, more critically, with their customers.

In 1908, the Model T resembled in appearance many other cars of its time. In his memoirs, Alfred Sloan mischievously put a photograph of the 1908 Model T immediately below a similar picture showing a similar-looking car: the 1908 Buick.[1] The simplicity of the Model T's design undoubtedly had advantages from a manufacturing point of view, and it was Ford's intention from the first that the car should be made in quantity. Using the narrow definition, the Model T may fairly be described as the first product of mass production. But when the car was conceived of in 1908, it was with prevailing – albeit changing – production methods in mind.

Mass production was evolved to produce the Model T in great quantities. Countless details of design may have arisen in direct response to individual processes incorporated into Ford's version of mass production. Casting or metal-stamping, for example, made some design decisions possible whilst precluding others on grounds of practicality or economy.

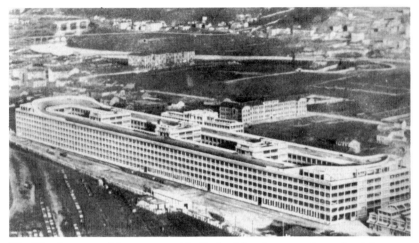

The Fiat factory at Lingotto, outside Turin. Manufacturers throughout the world looked to Ford's example. Modelled directly on Ford's Highland Park, work began on Giacomo Matté-Trucco's dramatic design – complete with rooftop test track – in 1916. Yet, as many European imitators discovered, smaller, less stable markets proved unsuited to Fordist mass production.

Some aspects of the design of the Model T can be attributed to the ways in which parts were handled on the assembly line or transferred from one line to another. The evidence of the Model T points, at best, ambiguously to the consequences of mass production for the design of mass produced objects, whereas the Model A, as well as many of the automobiles made by General Motors, seemed to indicate that mass production and visual sophistication were not incompatible.

General Motors' adoption of mass-production techniques in striving for the common goal of maximum production at minimum cost made sense; but so too did the pre-eminence given to appearance as a marketing tool. American ideals of a democratic, egalitarian society have always been tempered by concepts of the individual. The apparent uniformity and ubiquity of the Model T made it an emblem of mass production and of democracy. Yet, as noted earlier, once in the market-place, customers added accessories, stuck stickers on their bumpers and invented jokes and stories to make their cars 'individual'. In some senses, though in quite different directions, Harley Earl was employed to provide a physical foundation for the myths which the customer was invited to develop about the car he drove and his relationship to it (the invitation was seldom extended

The 1935 Chevrolet Master sedan. The car body gradually becomes fiction: its curvaceous smoothness has almost as much to do with its function of suggesting the imagined excitement of effortless speed, as with its task of efficiently protecting machinery and passengers from the elements. The actual radiator now does its work behind the image of a more emotive, fictional one.

to women). The Chevrolet of 1935 was mass-produced. The bodywork devised for it by Earl's team in the Art and Color department was intended, in part, to distract from this reality and, indeed, from the notion of the car as a machine-made machine. Instead of a 'real' radiator, visible and self-evident, the sinuous grille suggests that the air flowing through it is going to do something far more dynamic than simply cool a radiator. The design suggested elegance and speed and provided a mass-produced object with a distinctive, deliberately emotional character. It was a process which was to be more fully developed after the Second World War. For in the market-place, whatever its rational advantages or its associations with democratic ideals, mass production rarely excites.

Production technology evolves according to the perceived imperatives of capital and the market-place, while the product design is often, in large part, a consequence of the interaction of all three. At General Motors in 1935, the size and quality of the new dies required to press automobile roofs from single steel sheets demanded the outlay of large sums of money, as did the adoption two years later of all-steel bodies. To recover the expense, it was decided that many principal body parts would have to be utilised across the product range. One of the tasks of Art and Color, known as 'Styling' from 1938 onwards, was to design such pressings as were not shared, plus the necessary trimmings to maintain the distinctive brand identities.[2] Vance Packard noted that by 1956 most Detroit carmakers only brought out wholly new bodies once every three years, being content to remodel light clusters, radiator grilles and trim in the intervening two. Clearly, in a market which had been promised constant change, the manufacturer who could afford to retool for a completely new body shell each year would possess an advantage over competitors. This is what General Motors tried to do with their 1959 range. The prohibitive expense of such a policy – the cost in new dies alone would be enormous – was to be partly offset by still greater interchangeability of body parts across the brand names, a scheme which only General Motors, the largest of the American carmakers could then entertain. Joseph Callahan of *Automotive News*, reviewing the new models, noted that 'at least 12 important stampings are identical on all 5 cars.'[3] The bogey of excessive uniformity, habitually associated with mass production, was to be offset by 'Strips of painted metal . . . attached to the doors to produce distinctive sculpted looks',[4] while according to Callahan, 'Differences were also produced by using a variety of chrome trim, rear deck lids, quarter panels, bumpers and bumper guards.'[5] Meanwhile, as the surfaces of these automobiles pullulated with apparent variety and change, the mechanics they concealed altered very little from year to year. It was not uncommon for an engine or transmission design to last for twenty years. By utilising these major mechanical components across the brands, further economies could be secured.[6]

General Motors' objective was to force the pace of apparent change and thus make its competitors' products appear obsolete. Yet it would be hard to claim that this policy was peculiarly a consequence of mass-production technology; rather it was a function of the nature of the market which had been created and the levels of capitalisation which the mass production of automobiles on this scale required. Indeed, in the nineteenth

century, many of its technological, economic, design and marketing aspects had been prefigured elsewhere in Michigan. Furniture manufacturers clustered around Grand Rapids produced simple, machine-made forms which were ornamented with a range of 'glued-on' carvings in order to provide the richness, diversity and status which the buying public expected.[7] Closer still to the General Motors experience was that of American clockmakers. Identical brass mechanisms were to be found in cheap American clocks whose cases, 'built-up' in a manner akin to Grand Rapids furniture from machine-carved or stamped curlicues, 'marbled' columns and gilt capitals gave the illusion of difference or novelty. As Hounshell notes:

> When markets seemed to sag or competition pushed too hard, clock manufacturers introduced a new model. Hiram Camp complained about spontaneous changes that characterized the mature clock industry: 'the desire to make and sell great quantities has led the manufacturers to bring out new designs until dealers have become amazed and bewildered ... The expectation of something new prevents the sale of the old.'[8]

This is the tension, heightened by the high levels of mechanisation in the nineteenth century and explored continuously into the mass-production era of the twentieth. To secure economies in production costs, the manufacturing technology seemed to require ever greater rationalisation and simplicity of product, production in larger quantities and for longer periods; the market-place, with few exceptions, seemed to demand, or was manipulated to expect, product variation and regular innovation. It is tension which both production engineers and designers continue to address. The austerest of critics may see the exercise solely in terms of deceit and exploitation, passing off that which is uniform or essentially utilitarian as individual or emotionally exciting – not to mention more modern sins such as environmental profligacy in the consumption of raw materials beyond that which function and wear seem to require. Certainly, the object of the exercise is to secure a greater return on capital by selling more clocks or cars. But to the extent that a clock or car is experienced and enjoyed in the imagination, as well as in its functional, utilitarian capacity, the products which have emerged as a consequence of this tension have provided some of capitalism's liveliest entertainments. Quite how the reconciliation of the differing demands of capital, production strategies and the market-place is or is not achieved varies according to the culture in which the drama is played out.

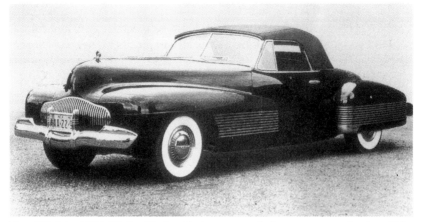

The 'Y' Job, 1937. Under Harley Earl, many techniques were evolved at GM for developing car body designs, including experimental 'Dream Cars' which could be used to test or stimulate public reaction to stylistic innovations before risking the expense of introducing them on production models.

By 1907, according to *The Motor Trader*, Britain was already overrun by cheap cars: 'Cheap and nasty is a trite style of summing up the de-merits of basing one's expenditure on quantity rather than quality ... In the motor trade it is somewhat remarkable to what extent this craze for cheapness exists. It permeates it thoroughly'.[9] Yet between 1906 and 1912, the impression that there was already too much competition in the small car market led makers like Sunbeam, Vauxhall, Singer and Vulcan to switch their attention from small to larger, more expensive vehicles. In part, companies took their cue from the fortunes of Daimler and Argyll, for while Daimler had achieved increasing success by concentrating on large, luxurious cars, Argyll's plans to make thousands of light cars seemed jeopardised by near bankruptcy. Though individual models tended to get cheaper during these years – probably reflecting increases in production efficiency – the average price of the range offered by each manufacturer climbed steadily. In an industry of short production runs and low output such a policy seemed to make sense, as the proportion of profit to be made on each large car was greater than that for its inexpensive counterpart. By 1912, *The Times* felt compelled to castigate British motor car manufacturers: 'There is a huge and hitherto untapped public who would buy and are beginning to buy from foreign sources – a really good cheap car. If a valuable market is not to a large extent to be lost at the outset,

the British manufacturer will have to set himself seriously to work to produce small cars as good as and as cheap as those now imported from abroad.'[10] On another occasion that year, it lamented, 'The fact is that there is no firm at present which has been sufficiently enterprising to lay down a large enough plant to make small cars in sufficient numbers to make their production really cheap.'[11]

Perhaps the most literal replications of Ford's extreme version of mass production were his own.[12] The British car-buying public had responded coolly to Ford's imported Models A and N, but when the Model T was introduced in small numbers from 1909, it became apparent that demand was strong. In 1911, Ford established a factory at Trafford Park, Manchester, to assemble Model Ts from imported knock-down kits, using the same stationary assembly techniques then employed in Detroit. From 1912 onwards, under the superintendence of Percival Perry, the nature of the operation moved gradually from pure assembly towards manufacture, in particular, of such parts as bodies, petrol tanks, radiators and exhaust pipes which were bulky or fragile and difficult to transport. The high level of deskilling which Ford methods exhibited even then was not met without resistance: coachbuilders, sheet metal workers and tinsmiths all contributed to strikes or the threat of them, and their action culminated in a lock-out at the body shop in 1913 which lasted for twenty-two weeks. Both Sorensen and Ford visited Perry in 1912. Part of their strategy, apart from sacking union members, was gradually to increase the wages of those who remained. Given that these rises predate the introduction of the $5 day at Detroit in January 1914, a case can be made for events in Manchester significantly informing Ford's labour strategy at Highland Park.[13] Less than twelve months after the first experiments in Detroit, the first moving assembly line in Britain was installed in Manchester in September 1914.[14]

In 1911 the Model T was extremely competitively priced at £135, and for the first time it sold in large numbers. The British motor trade, though comparatively small compared with France, demonstrated once again its responsiveness to perceived market trends with a renewed interest in small cars. The Model T was joined in 1912 by the Singer 10 at £195 and the Standard 9.5 at £175, and in 1913 William Morris offered the Morris Oxford at £165. That same year America supplanted France as the world's largest producer of automobiles. By the outbreak of the First World War, one fifth of the models offered by British manufacturers were priced below £200.[15]

How appropriate was Ford's version of mass production to the British context? In trying to replicate his American operation in detail, Ford succeeded only in bringing his British operation to the edge of oblivion. Circumstances in Britain differed from those facing the company in America. Most obviously, the British market was but a fraction of its American counterpart. In 1913, when Wolseley, Britain's largest carmaker (after Ford's Manchester enterprise) made some 3,000 cars, Ford in America made 202,667, or nearly thirteen times as many cars as the ten largest British producers put together.[16] Ten years later, when the total output in Britain had climbed to 182,000, Ford alone made nearly 2,000,000 vehicles.[17]

During the First World War, production at Manchester totalled some 50,000, far outstripping Ford's British-owned rivals. As the British arm of the business developed, however, it became apparent that Ford's faith in the universality of his production and product-design strategies was misplaced. In trying to impose his fiercely anti-union, high-wage, hire and fire system of labour relations on his British managers, he failed to acknowledge how the different background and expectations of British labour might be accommodated or exploited. Arguably, the cultural gap between Ford's managers in Detroit and their largely immigrant, hetero-geneous labour force was greater than that between a British manager and a British worker. Commenting on American production methods towards the end of the First World War, one British engineer observed,

> In America, I understand, the labour available is much more amenable to systematised working. In England there is difficulty in getting a man to do exactly what he is told, because he is apt to think a great deal more for himself than do his fellows in America. Therefore the system in this country has to be more elastic and less precise than many American systems are said to be.[18]

Detroit was scandalised to discover in 1923 that, in order to foster contentment and reduce staff turnover, Ford workers in Britain were al-lowed to operate self-help welfare programmes in the factory and to smoke on the job. The high wage rates imposed on British managers far ex-ceeded what was required to surpass local norms. In 1928, Percival Perry, an early advocate of Ford's high wage policy, complained, 'Our present rates are past even the limits of philanthropy.'[19] But the main reason why Ford in Britain did not fulfil the promise which strong demand for the Model T before the First World War seemed to hold, was the failure to recognise the inappropriateness of the Model T for the British market. In

Ford's view, the Model T was a universal design, to the extent that until 1923 all Model Ts produced for the British market were left-hand drive; what was good enough for America was quite good enough for Britain. With the introduction of a host of British-made small cars, the Model T seemed increasingly large and clumsy. For too long Ford resisted pressure from his British managers to introduce a new, smaller car. Ford's market share in Britain dropped from 24 per cent in 1913 to a mere 4 per cent by 1929.[20] In Detroit, the high wage policy had been predicated on the basis of high volume demand. In Britain it was pursued even though demand was weak. The Ford factory built at Dagenham between 1927 and 1932 was intended to be a one-tenth scale replica of the River Rouge plant. But despite the introduction in 1932 of the Model Y (the first small 'British' Ford) as part of a product policy more reflective of local needs, Dagenham was not operated at full capacity until after the Second World War. Throughout the 1930s, high capital investment, weak demand and a policy of ruthless price cutting meant Ford in Britain faced an almost constant cash crisis.[21]

It is instructive to compare Ford's approach to the British market with that of General Motors.[22] Some Chevrolets were assembled in Britain in 1924, but having failed to buy Austin, in late 1925 General Motors bought Vauxhall instead. The decision to acquire an existing British firm was, in part, a measure of their belief that British expertise could be profitably employed in wooing the British consumer, who might hesitate to buy an overtly American product. Vauxhall had made large expensive motor cars such as the 'Prince Henry'. The first assembly line had been introduced at Vauxhall in 1925, when the firm employed 1,400 workers and made only 30 cars a week. Under General Motors, methods of production, sequences of machinery and levels of output were planned in far greater detail in advance of actual production. A. J. Hancock, the British works manager, was sent to Detroit in 1926. He was impressed with the way in which detailed scale models of factories were used as planning tools. By 1928 each department had been reorganised on 'flow' principles and assembly was done on tracks. Whenever possible, Hancock came to advocate mechanised assembly lines as 'quantity per hour gauges'.[23]

Production at Vauxhall rose to about 130 cars a week with these improvements. This volume of production, though modest compared with levels to be found in Detroit, was consistent with demand for the types of car the company made. The fact that it was felt to be good economics to invest in moving assembly lines makes it plain that their use was not

and need not be confined to high-volume producers. A number of small-scale British car makers shared this belief. The elements which, combined, added up to mass production were by no means wholly alien to British production engineers. On the contrary, by 1914 many were already familiar in detail with the most advanced American practices, including interchangeability, the sequential arrangement of manufacturing equipment, single-purpose machine tools, deskilling of the workforce through the division of labour and high levels of mechanisation. This was especially true among manufacturers of bicycles – like the motor car, a new class of product – and in the Midlands, where poorly organised workers offered little opposition to the introduction of new machinery or working practices.[24] Among British Motor manufacturers, Belsize, Dennis, Humber, Rover, Riley, Star, Singer, Sunbeam, Swift, Daimler and Rudge had close links with bicycle manufacture.[25]

Paradoxically, it was the experience of the bicycle trade which helped to create what to many has seemed the very conservative attitude of motor manufacturers towards high capital investment and risk-taking in terms of product innovation. In the early 1890s, it had looked as if the market for the safety cycle was insatiable and manufacturers scrambled to exploit it. By late 1900, over-capacity led to a collapse of the market, with many companies facing ruin. British motor car manufacturers, eager to avoid a repeat experience, believed the answer lay in being able to respond quickly to variations in market demands, in terms of both magnitude and product type. The demise of the promising Argyll company in 1907 seemed to confirm these fears. The company had invested heavily in special purpose machinery – associated with American practices – for the production of thousands of light cars, just as the market experienced one of its periodic downturns in demand.

The first successful British mass producer of motor cars was William Morris. Like his subsequent rival, Herbert Austin, Morris's success depended more on the extent to which he modified American practices, rather than on how closely he imitated them.[26] In 1914, Morris visited America twice[27] to study at first hand American manufacturing techniques, but his plans were interrupted by the First World War. Echoing Ford's experience, Morris began as an assembler and only gradually moved into production as he bought up his suppliers. The first assembly line was introduced in 1919, but unlike those at Ford, it was hand-powered and remained so until 1934.[28] The division of labour was not as thoroughly fragmented as at Ford, and with many of the workforce recently recruited

from rural Oxfordshire, it was thought that piecework, rather than the day wage system, was essential to secure high levels of productivity. With a hand-powered assembly line, workers themselves were responsible for the rate at which a chassis, rear axle assembly or engine block might be pushed along, rather than having the rate of productivity fixed by management through the agency of a powered assembly line. Like Ford, Morris concentrated between 1919 and 1928 on just one model, the 11.9 horsepower Morris Cowley. But, like General Motors in the States, he continued to rely more heavily on bought-in components – concentrating on the business of assembly – in contrast to the more vertically integrated Ford. Morris did not have to invest heavily in manufacturing plant whose costs would only be recovered if there was a sustained high demand for a relatively unchanging product. Productivity and production were increased gradually: 2,000 cars were made in 1920, rising to 20,000 three years later and some 60,000 by the late twenties – modest in scale by American standards. Critically, in the matter of body production, Morris continued to favour 'European' craft techniques. In the medium term, this 'failure' to mechanise made bodies more expensive, but in a largely middle-class, quality-sensitive market of the British size, that was more than offset by the advantages of a high-grade product and the flexibility it gave him continually to vary the body shape of the Cowley.[29] Morris was conscious of the distance between his own and Ford's practices. 'Let me say at once that our success has not been achieved by what is commonly called "mass production". I prefer to spell "mass" with an "e". So far mass production has meant merely *mess* production when applied to motor cars in this country.'[30]

Yet, experiments with automatic hydraulic transfer and clamping machines (machines which both move components from one machine to another and clamp them into position) foreshadowed innovations which only became commonplace after the Second World War. Automatic transfer machines could, in effect, turn the production plant into one single, complex machine. According to the engineer responsible for their introduction, they were abandoned at Morris only because the hydraulic systems of the day proved inadequate.[31]

Unlike Ford, Morris evolved production technology which accommodated a certain measure of control by workers over the pace at which they worked and which allowed sufficient flexibility to cater for the special characteristics of the British market. Herbert Austin went further, believing that motivating a workforce was a viable alternative to the most up-

to-date assembly machinery.[32] Not that he was unfamiliar with it. His major innovations in production techniques and in product design – as seen in the Austin Seven – followed directly from his visit to Detroit in 1922. 'I saw the famous Ford shops . . . the point which interested me and made me marvel was the way in which everybody seemed to be trying to do their best.'[33] He felt that the mixture of races working at the Ford plant and the atmosphere of 'push' were Ford's main keys to success, rather than the production technology itself. Manufacture of the Austin Seven exploited flow production techniques and, from 1924, manual assembly lines. These were gradually powered from 1928 onwards. Once again, a reluctance to take this last step may partly be accounted for by the belief that high levels of motivation, and therefore efficiency, were dependent on piece-work and the bonus schemes which went with it. Like General Motors in America, Austin relied more heavily on general-purpose, rather than single-purpose machine tools. C. F. Engelbach, head of production engineering at Austin for most of the twenties, explicitly linked this to the nature of the market for cars in Britain and the need for flexibility in product design:

A change has come over the spirit of our dreams of quick-time floor to floor production performances, accompanied by the spectacular removal at high speeds of chunks of metal to the musical ticking of stopwatches . . . Rapid changes in fashion and ideas have slowed up the progress of the special single operation machines. Continuous high production is too uncertain for special machines to be further developed. Designs have to be changeable at short notice . . . [and] at present there is no possible market likely to develop sufficiently that will lead to the extension of such specialised tool methods.[34]

Whereas no one in Britain, save Ford himself, sought to replicate in detail mass production as he had practised it in America, elsewhere in Europe there were those who attempted just that. In France, for many years Europe's largest producer of cars, war precipitated moves towards mass production.[35] The war effort demanded immense quantities of standardised munitions as well as transportation in the form of trucks, tanks and private cars for military personnel. André Citroën visited Ford in 1912. During the war he was eminently successful in making one size of shell at his factory at the Quai de Javel in Paris, itself built from scratch in eight months in 1915. Louis Renault first visited America in 1911, and in the war years he made a range of products for the military. Marius Berliet built trucks in great quantity at Lyon. Both he and Robert Peugeot sent

their engineers to visit Ford's factories. In 1917, Berliet introduced two moving assembly lines at his massive new factory near Lyon.[36] In wartime, production techniques which relied less on skilled engineers had their attractions to manufacturers increasingly reliant on unskilled women for their pool of labour. Similarly, under such circumstances, conveyor belts proved useful in the manufacture of, for example, heavy shells.

The capital required for wartime expansion came from the French government, who, in turn, were the purchasers of the goods produced. Clearly, whatever the technological resemblance to American practices, plant was not laid down in response to a demand from the public. After the war, Berliet announced that he would be making only one motor car (a copy of a Dodge) and one truck. Citroën began introducing assembly lines in 1919,[37] and following his second visit to Ford in 1923 – at a time when Ford was at the height of his post-war success – Citroën decided to adopt a one model policy. Yet the nature of the French market made him hesitate. In practice, the attempts of both Berliet and Citroën to reproduce Henry Ford's successes in France brought near financial ruin. Berliet suffered relegation to the second league of French motor manufacturers and Citroën – despite successfully securing nearly a third of the French market – only survived with support from his wealthy family and associates.

German prowess in car manufacture had tended to concentrate before the war on large expensive cars such as the Benz, for which there seemed to be a ready market not only at home but in exports to Austria-Hungary and among the aristocrats of Imperial Russia. By contrast, Opel, makers of both sewing machines and bicycles, had made a moderately successful small car before the war and in the recovery which gradually followed defeat set about trying to exploit the small car market. Following the relative political and economic stability achieved in 1923, Opel introduced assembly lines in 1924 and renewed most of its machine tools in the following four years. Even so, according to James Laux, interchangeability had still not been achieved, and its most successful model, introduced in 1924, was a copy of Citroën's five-horsepower motor car introduced two years earlier.[38] Low import tariffs had led to Ford, General Motors and Chrysler building assembly plants at Berlin in 1926. In 1927, the government raised import tariffs. General Motors eventually responded by taking an 80 per cent share in Opel in 1929, deciding, as with Vauxhall in Britain, to make a specifically European product.

Although Italy ranked behind France, Britain and Germany before the

First World War in terms of output, it was an Italian who proved to be one of Ford's most persistent and successful imitators. Giovanni Agnelli went to America in 1906 and again in 1912, when he visited Ford.[39] The Fiat Zero, developed between 1912 and 1915, had bodywork designed by the Farina coachworks. It bears a passing resemblance to the Model T and was intended for manufacture in volume.[40] But although flow production was being developed at the Fiat Centro factory by 1913, a diverse product range meant that the company could not benefit from the widespread standardisation with which the system is associated.[41] By the outbreak of war, Fiat was Italy's largest carmaker with an output of some 4,644 in 1914. However, the Zero was never built in great numbers.

As in France, the war was instrumental in stimulating both growth and developments in production techniques. The increase in demand for vehicles culminated in 1916 with construction work on a new, thoroughly up-to-date factory. The Lingotto plant outside Turin is often held up as one of the most faithful imitations of Ford's Highland Park. Matte Trucco's design has been justly celebrated for its imaginative use of reinforced concrete, its daring, coherence and modernity. The engines and bodies flowed upwards through separate assembly sequences on the first four floors, before being united with one another on the fifth and driven out onto the test track built on top of the roof. The undoubted drama of the conception was only partly reflected in the reality of production. Unlike at Highland Park, making only one model was unrealistic, given the fluctuations in demand; accordingly, Fiat offered the public a range of products. This contributed to the difficulties of achieving the planned daily output of 300 vehicles, even though the manufacturing machinery was continually updated. The system of moving assembly lines proved problematic and was not fully operational until 1925, three years after the building had been completed; and the new production technology led to a series of labour relations problems.[42]

Neither Renault, who had adopted moving assembly lines in 1922, nor Peugeot persisted with expansionist policies once the realities of the immediate post-war market in France became apparent. Renault was, perhaps, the most vertically integrated of French carmakers and to that extent closest among French carmakers to Ford's example; yet, like Fiat, Renault ignored the lure of a single model and chose to offer not only a range of cars, but other products as well. By making commercial vehicles, tractors, aircraft engines, railway carriages, and tanks as well as cars, risks in the market-place were spread.[43] In their attempts to imitate Ford,

both Berliet and Citroën had invested in large quantities of American-made manufacturing equipment. Yet without the expertise, the machinery was of limited value and both companies experienced considerable difficulties in achieving American standards of interchangeability. For while less skill might be needed to manufacture and assemble, greater skill was needed to keep the equipment and its accompanying gauges accurately adjusted. In addition, as Sylvie Van de Casteele-Schweizer has pointed out, 'these high-output machines, which had been conceived [of] for the vast American market, generated tremendous over-capacity in France. At Citroën and Berliet in 1925, for example, the presses stamped enough in one hour to supply the daily production of the factory.'[44]

Such a startling mismatch between production technology and market realities is partly a measure of the faith that many manufacturers had in Ford's example. In 1928, Louis Renault, faced with falling profits from carmaking, made a return visit to America with members of his research and methods departments. On his return, work began on the Ile Seguin factory which was to incorporate assembly lines from the first. Citroën visited Ford once more in 1931, when he returned 'dazzled' and thoroughly reorganised his factory.[45] But his faith both in expansion and in Ford as a model motor manufacturer was unable to sustain him through the depression. In 1935, the banks obliged Citroën to hand over control to the more conservative management of the Michelin family.

Despite fairly constant modernisation and a range of labour efficiency strategies, Fiat came to believe the plant at Lingotto unsuited to their evolving needs. Yet, once the depression began to abate, it was to Ford's example that the ageing Agnelli turned once more. After his return from a trip to America, it was decided to build a completely new factory in a suburb of Turin. As Lingotto had been modelled on Highland Park, so the Miafiori plant was modelled on the River Rouge; or, more realistically, given its relation in terms of size to its American progenitor, Dagenham. It was laid out on a single floor. At Lingotto, the making of components often took place in premises away from the main assembly lines. At Miafiori, the component production lines were laid out at the sides of and fed into the main assembly line, reducing unnecessary transportation of materials or parts and providing space for stocks of components to be kept close at hand. Significantly, while the equipment was of the most modern American manufacture,[46] the plant was intended from the first to be flexible. Excessive mechanisation was avoided in case evolving demands quickly made such equipment obsolete; overhead conveyors, for

example, were not installed, on the grounds that they were too task specific.[47] And in an increasingly militaristic climate, the switch to military purposes must have seemed, if not a certainty, then at least an imminent possibility.

By 1939, Britain had become the second largest carmaker in the world, with France relegated to fourth position behind Germany. Hitler's drive towards autarchy and economic recovery featured a number of policies which favoured the German car industry. The depression itself had precipitated mergers among some of the older firms, most notably, the creation in 1930 of Auto-Union from Horch Audi, Wanderer and DKW. Nearly 1,860 miles of *Autobahn* were built before 1939 and over 10,000 miles of other roads were rebuilt. Orders for vehicles from the Nazi government and a new, specifically German model named the Eifel helped revive the fortunes of Ford's German enterprise, while the state sponsored the development by Ferdinand Porsche of the startlingly original Volkswagen. The intended output of one and a half million cars by 1942 never materialised, however, and those who had placed deposits for Volkswagens never saw their money again.[48] To greater or lesser extents each nation state provided a context within which car industries might prosper or founder, from the 33.3 per cent tariff on imported cars introduced in 1915 to protect British manufacturers, to the more direct protection and encouragement offered by Fascist governments in Italy and Germany, where economic and strategic considerations were coloured by the equation of modern, technological prowess with national pride and international propaganda.

Whatever its commercial advantages, the ability to adapt to changed demands can have profound strategic consequences in wartime.[49] Ford's noisy and inglorious efforts with the Willow Run plant contrasted poorly with General Motors' performance. For not only did they succeed in keeping production costs down through mass production, the constantly changing demands of the military for goods virtually unknown to the carmaker were successfully accommodated. Both the manufacturing plant and the organisational and management institutions first developed by Sloan in the 1920s made this possible. Remote from the actual theatres of war, the American motor industry prospered. After defeat in 1940, the French industry was damaged by the appropriation of equipment and engineers by the occupying German forces, while inside Germany producers were constantly hampered by shortages of raw materials. In Italy, Fiat under Agnelli made considerable profits.

Many had been planning for peacetime conversion while the war still raged. General Motors decided that demand after the war would be strong, that the programme of developing overseas plants to produce vehicles appropriate to local markets should be pursued, while for the home market a fairly complex, sophisticated design strategy was devised by Earl and his team at Styling. By contrast, in Britain most carmakers, in consultation with the Board of Trade, foresaw a weak market, very little changed in character from that which had existed before war broke out. As Fridenson notes, 'Sir Roy Fedden's proposed three-cylinder, air-cooled, rear-engined car, developed independently of the carmakers, aroused skepticism and was allowed to die.'[50]

Both Ford and General Motors had built assembly plants in Japan before the war.[51] At the Imperial government's insistence, Japanese firms such as Nissan and Toyota were encouraged to make their own cars. Techniques and even some personnel were imported from Detroit. Once the war in the Pacific was brought to its spectacular and controversial climax at Nagasaki and Hiroshima, few would have predicted that Japan would come to dominate the world market for cars. Yet in confining the defeated Japanese to the manufacture of peaceful, rather than military goods, the victorious United States simultaneously relieved Japan of the financial burden of maintaining large armed forces while effectively defining the means by which national pride might be recovered. In addition, as the occupying forces roamed the country in their sturdy American-made trucks, jeeps and staff cars, they unwittingly advertised to an entire nation the potential advantages of technically sophisticated products. The creation of a modern, efficient motor industry was seen by the Japanese as the foundation for post-war industrial and economic recovery across the entire manufacturing sector.

After independence in 1952, the Japanese government imposed heavy import tariffs of up to 40 per cent and other restrictions in order to protect the fragile recovery of the home producers. In the first instance, the Japanese looked to Detroit or its European counterparts to study what then seemed best manufacturing practice. Eiji Toyoda spent three months at River Rouge, while personnel from Nissan visited the Austin factory at Longbridge. To the intensely curious visitors, a British tea break – where each worker had his own mug – was viewed with disbeliet. Through the auspices of the Japanese Ministry of International Trade and Industry or MITI, firms were encouraged to develop close links with Western

producers, on the clear understanding that they should achieve 90 per cent domestic manufacture within five years. Thus, in 1953, the car applauded as it rolled off the post-war production line at Nissan was, in everything but name and origin an Austin A40, every bit as bulbous as its English counterpart.

When the Japanese visited Western carmakers in the 1950s, they were undoubtedly impressed by the sophistication of the plant and the stringency with which materials and dimensions were tested. Eiji Toyoda wrote, 'Throughout assembly, everything is tested again and again . . . this is the way to produce perfect cars.'[52] With a protected home market, largely undeveloped in terms of car-ownership, rising incomes and a strong desire on the part of many Japanese to own a car – virtually any car – an opportunity was contrived which had parallels to that which faced Ford in 1908. While different in overall extent, Japanese manufacturers, like Ford, could exploit the economies of large-scale production of standardised products.[53] Initially, the technical specifications and visual sophistication of the models on offer did not bear comparison with state-of-the-art vehicles then being produced elsewhere. To Western eyes, the 1955 Japanese designed Toyota Crown RS or Nissan 110 seemed little more than naive pastiches of American or European styling ideas, almost comical in their crudity. Not that many Western eyes saw them. In the 1950s, the protected Japanese makers were generally content to compete fiercely with one another and build a secure domestic market. When, in 1957, Toyota first tried to export to California, Donald Frey at Ford thought their product 'a piece of junk'.[54] Nissan sent a team to America to test their Datsun cars under US conditions. Toyota were disheartened to discover that their cars could not gather sufficient speed to join traffic on Los Angeles freeways.

Meanwhile, in Europe and America, pent-up demand generated by wartime shortages had ensured that there were sellers' markets. In the United States, this situation lasted until about 1953.[55] As noted earlier, General Motors struggled to reconcile production technology with the perceived need for the appearance of change. This emphasis on the emotional rather than the technical merits of automobiles seemed vindicated by General Motors' ability throughout the 1950s to maintain their position of pre-eminence. The more conservatively styled products of the Chrysler Corporation led to a decline in that company's market share, while Ford flourished just enough dramatic designs to secure for themselves an increase in sales of about the same size as that which Chrysler

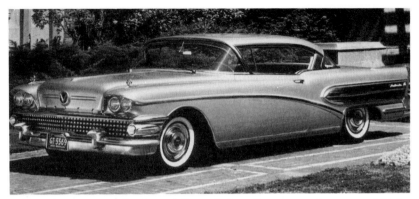

Buick Roadmaster, 1958. Form follows fiction. Contrary to the tenets of high Modernism, there proved to be nothing inherent in the techniques of mass production which would guarantee the 'natural' evolution of sober, refined forms. Capitalism used the machine to mass-produce fictions. The open-mouthed horror of the Moderns never fully abated, despite critics like Robert Venturi and Reyner Banham.

lost. Clearly, in a market static in terms of volume, where few cars were needed to replace those actually wearing out and where the public perceived little difference between the makes as far as technical excellence was concerned, the trick was to design cars which delivered just the right emotional kick. However aesthetes might wring their hands, for about a decade designers and car-buyers shared and understood a potent common language of forms, signs and symbols. Moreover, it was a distinctively American tongue, which in an age of national confidence, no manufacturer elsewhere in the world seemed fully either to understand or speak. Yet towards the end of the fifties, there were signs that this tirade of populist histrionics, with comic-book tail fins and ballistic chrome, could not be sustained forever. As Thomas Hine observes, what had started out as gradual, planned-for change became increasingly frenetic and desperate. The desperation is almost palpable in the anguished face of Ford's spectacular flop, the Edsel – named after the founder's unfortunate son – which must surely rank as the auto industry's unwitting homage to Edvard Munch.

Innovations in production technology continued in America. Automatic transfer machines, with which Morris in Britain experimented before the war, had become a reality when General Motors introduced them on the Buick cylinder block line in 1947, closely followed by Ford at their

Cleveland engine plant in 1948. This last is usually recognised as the first fully automated engine assembly line. For manufacturers, they held out the prospect of increased productivity – contemporaries also predicted large savings in labour costs and floorspace – but at the same time they increased capital expenditure. The post-war success in Britain of Ford at the expense of Austin and Morris has been partly ascribed to Ford's willingness to invest in new capital equipment, rather than pay share-holders high dividends.[56] But increased capital expenditure on automatic transfer machines meant – especially in the medium-sized operations of Europe – retaining plant for longer to recover investment. Model renewal in Europe was noticeably slower than in America.[57] In addition, automatically linking each stage of production and creating one vast machine had the effect of making the system vulnerable to what would otherwise be minor disruptions. In Britain, this technological development meant that strikes, official and unofficial, became more powerful bargaining tools against managements faced with strong demand for their products and for whom productivity was thought to rest largely on keeping assembly lines running. Gradually, in the 1970s and 1980s, management abandoned piece-work which had (successfully) been at the heart of British mass-production practice for thirty or more years, in favour of a more Fordist day wage.

In Japan, by contrast, the flexible and apparently harmonious working practices for which Japanese industry is renowned were only secured after a long and bitter dispute between the national carworkers' union and the manufacturers. At Nissan, management refused to negotiate and barri-caded themselves inside the factory for forty-five days. The unions lost. Ever afterwards, Japanese managers exercised great power and offered their workers job security and paternalistic welfare support. From their point of view, managers felt free constantly to review working practices in search of ever greater productivity. With limited plant, all equipment had to be fully utilised. The large panel-stamping presses, for example, were efficient in Detroit because they were used for days and sometimes weeks at a time stamping out the same component. Only then would the dies be changed, so that another type of panel could be stamped out. The change-over took up to three hours. The same press in Japan might only be called on to produce some hundreds of door panels, before it switched to turning out petrol tanks or roofs. While the dies were changed, the workforce was idle. At Toyota, Taiichi Ohno reduced the change-over time to a matter of six or seven minutes.

Countless other efficiencies were introduced. Most famously, Taiichi Ohno enhanced the continuous flow which automatic transfer machines made still more desirable, by developing a major post-war refinement in mass-production practice, known, even in its country of origin, as 'Just-in-time'. Workers on the assembly lines drew components only as and when they were required, leaving a form requesting the same number of components to be manufactured. Thus, parts were only made and delivered to the assembly line as and when required (Just-in-time). In this way, it was possible to avoid tying up useful capital in stocks of parts waiting to be used. In Japan's tough post-war climate, this was a vital consideration.

In America, the drift towards smaller cars or 'compacts' had begun tentatively in 1960. Ralph Nader mounted a famous and successful attack on one of these, the rear-engined Chevrolet Corvair. Yet the way in which his campaign undermined confidence in the industry and in American car culture as a whole, served to weaken the appeal of its embodiment, the 'gas-guzzling dinosaurs'.[58] As Hine remarks, in the ensuing years these became not so much extinct as 'domesticated'.[59] Echoing anxieties in American political life, enthusiasm for crude militaristic baubles declined and colour schemes became less brash. Whereas European imported cars had tended to be in the luxury or sports car fields, throughout the sixties the proportion of small-sized European imports increased. The Volkswagen, in particular, enjoyed a certain puritan chic amongst intellectuals. This trend was given a major boost by the 1973 oil crisis, which more than doubled the price of a US gallon of petrol. In this chastened climate, the products which the Japanese carmakers by then had on offer enjoyed considerable appeal, for whereas American carmakers had traditionally emphasised the emotional thrills their products could supply, the Japanese were successful in fostering a reputation not only for fuel efficiency but for technical excellence, reliability and value for money. These qualities sprang directly from efficient use of the most advanced production technology, stringent quality controls and – at a social cost yet to be reckoned with – a flexible, quiescent labour force. In addition, following Volkswagen's example, great stress was laid on after-sales care. By 1980, 20 per cent of the American market was Japanese.[60]

Historically, increased levels of automation have tended to work towards improved productivity, provided a single product is made in sufficient volume and for a sufficient length of time. Flexibility tends to be reduced.

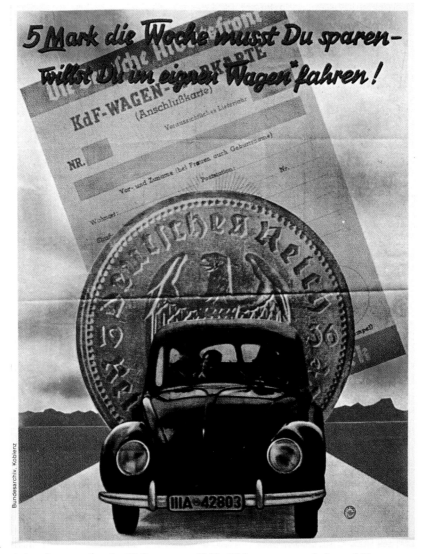

Advertisement for the Volkswagen, 1938. Hitler, a great admirer of Henry Ford, conceived of a people's car for Nazi Germany. The irony of the car's subsequent popularity with American intellectuals, many of them Jewish, has not passed unnoticed. It was marketed as a 'rational', inexpensive, democratic alternative to Detroit barocco.

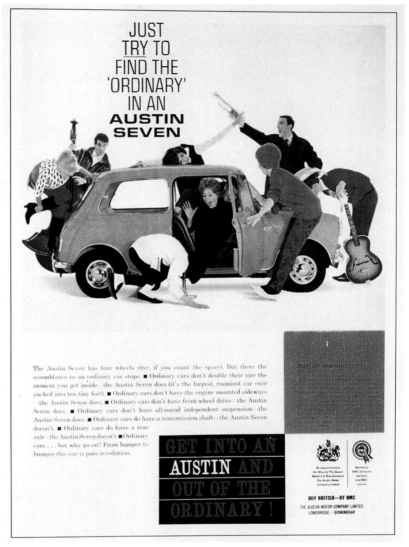

Advertisement for the Mini, 1959. Like the (original) Austin Seven, the Fiat 500, the Volkswagen and a handful of other car designs, the Mini sold in large numbers over many years and was seen was a democratic emblem of 'mass' personal transport. In that sense these were spiritual descendents of the no-nonsense Model T ideal. For about a decade, the ideal was the norm, whereas the Model T's successors attract attention against a background of regular stylistic changes.

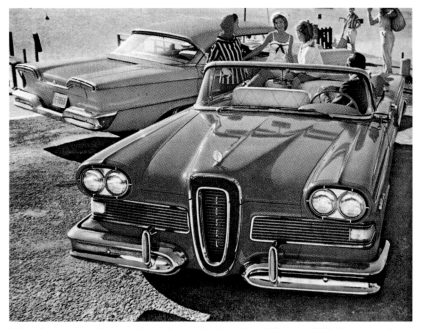

Miscalculations of the industrial imagination. Ford Edsel, 1958. For capitalism to survive, we must join in the conspiracy. The power of manufacturers and advertisers to manipulate the buying habits of their customers is limited. For a design to succeed, it must evoke positive responses – rational or irrational – among potential buyers. Famously, the massively researched Edsel did not.

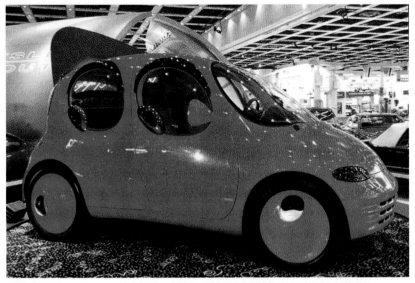

Chrysler Expresso, concept car, 1994. This is intended to be a taxi. The expressive and irrational flourish in an age of half-hearted approval of technology and its perceived consequences for the environment. Still more than its stylistic antecedents, such as the Nissan Micra or Vauxhall Corsa, it is a warm, cuddly cartoon character. It is not a machine, nor was it made by one.

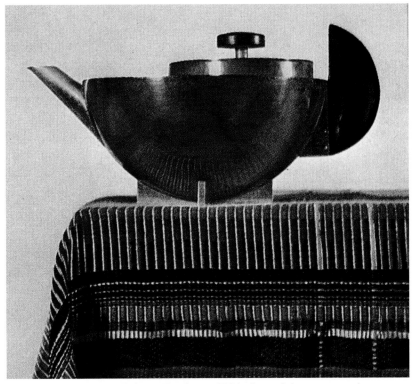

Marianne Brandt's tea infuser, Bauhaus, 1924. One of the most poetic expressions of Platonic, geometric forms derived partly, it was believed, from the immanent logic and technological reality of the Machine – sentiments which sit oddly beside the craft techniques of the actual object's manufacture.

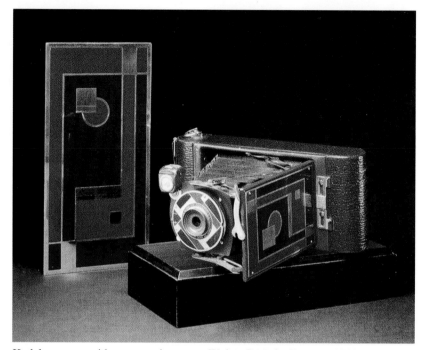

Kodak camera with presentation case, Walter Dorwin Teague, 1930. Lewis Mumford fumed at the 'studious botching of the Kodak'. Mumford thought the camera already had a 'natural' form, whose purity and integrity could only be sullied by inexpensive changes in finish of the sort shown here.

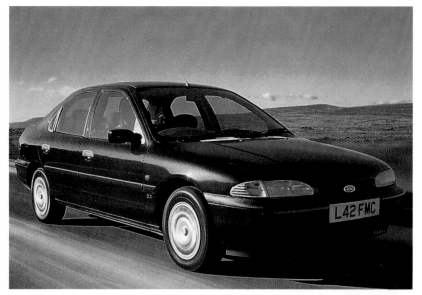

The Ford Mondeo is an example of the 'glocal' car, a single, generic design which, largely because of the increased flexibility afforded by modern computer technology, can be manufactured in a bewildering variety of forms according to the perceived needs of local or niche markets.

Persistent machine-made fictions. Long despised by critics, the electric 'coal-effect' fire still (1994) sells well. This Suncrest Symphony with Optiflame, is available, the catalogue tells us, in rich 'mahogany effect suite with filligree features . . . also available in honey oak effect'.

In the last thirty years, developments in computer technology have meant that this constraint need no longer apply. In the early 1970s, the earliest, usually single-action, robots were introduced in Japan, the United States and Europe. They replaced labour in specific manual tasks, such as welding or paint spraying, but their inflexibility meant they were only economic for high-volume production. When, a few years later, numerically controlled robots (NCR) were introduced, it meant that robots could carry out more complex tasks and, significantly, be easily reprogrammed when other tasks were required of them. In time, whole production lines, as well as the products they were to make, were conceived of from the first with robotic techniques in mind. In their most sophisticated forms, computers enable the process of design to be intimately linked to control of the eventual manufacturing plant (computer-aided design and manufacture or CADCAM).

Automation and robots have increased productivity by cutting labour costs. To some manufacturers, they have the added attraction of reducing their dependence on the co-operation of their workers. In 1979, a decade of conflict at Fiat's Miafiori plant culminated in the decision of the new managing director, Cesare Romiti, to lay off some 23,000 workers while robots and other automated machinery were installed.[61] Automation means the number of skilled posts required increases, but opportunities for unskilled labour are disappearing. The fear in the past was that assembly line workers might become like soulless robots. Today, thousands of them have been replaced by actual robots and their spiritual well-being is more likely to be threatened by unemployment.

Automation and robotics have improved levels of precision and quality, which not only reduces wastage but also makes new design strategies possible. Simplification of the product is only one of these. In 1983 – the first year of profit for Fiat after their wholesale robotisation – the 127 was replaced by the Uno. The 127's 276 body parts had been spot welded together at 4,280 points, 72 per cent of which were achieved automatically; the body of the Uno, by contrast, was assembled from 171 elements with only 2,692 spot welds, 99 per cent of which were achieved automatically and about a third of which were carried out by robots.[62]

In its mature form, automation is the central tool of an industry searching for ever greater flexibility and responsiveness. In this context, increased productivity, while among its principal attractions, is not perhaps its most significant dividend.

The twentieth-century manufacturer

Notes

1 Alfred P. Sloan, *My Years with General Motors* (London, 1972), figs. 62 and 63.
2 C. Edson Armi, *The Art of American Car Design, The Profession and Personalities* (Pennsylvania and London, 1988), p. 6.
3 Joseph Callahan, *Automotive News*, 29 Dec. 1958, p. 13, quoted by Vance Packard in *The Waste Makers* (New York, 1963), p. 70.
4 Packard, *The Waste Makers*, p. 70.
5 Callahan, quoted by Packard, *The Waste Makers*, p. 70.
6 Steven Tolliday and Jonathan Zeitlin (eds.), *The Automobile Industry and its Workers, Between Fordism and Flexibility* (London, 1986), p. 6.
7 John Heskett, *Industrial Design* (London, 1980), pp. 59–62.
8 The quote from Camp comes from John Joseph Murphy, 'Entrepreneurship in the Establishment of the American Clock Industry', *Journal of Economic History*, 24 (1966), 210; quoted by Hounshell, *From the American System*, p. 60.
9 'The quest of the cheap', *Motor Trader*, 13 Nov. 1907, p. 407; quoted by Wayne Lewchuck, *American technology and the British vehicle industry* (Cambridge, 1987), p. 114.
10 Quoted by Peter Pagnamenta and Richard Overy, *All our working lives* (London, 1984), p. 218.
11 Quoted by Lewchuck, *American technology*, p. 117.
12 Much of the following discussion of Ford's British activities is drawn from Lewchuck, *American technology*, pp. 152–8.
13 Lewchuck, *American technology*, p. 154.
14 James Laux in Jean-Pierre Bardou, Jean-Jaques Chanaron, Patrick Fridenson and James Laux, *The Automobile Revolution, The Impact of an Industry* (North Carolina, 1982), pp. 62–3, notes that chassis at the Sunbeam factory in Wolverhampton were moved mechanically from one work station to another in 1913. Output was then less than 2,000 a year.
15 Lewchuck, *American technology*, p. 117.
16 Lewchuck, *American technology*, p. 117. Ford's Manchester factory made 6,139 cars that year, according to Tolliday and Zeitlin, *The Automobile Industry*, p. 33.
17 Tolliday and Zeitlin, *The Automobile Industry*, p. 32.
18 C. S. Bayley commenting on a paper presented to the Institute of Automobile Engineers by A. W. Reeves and C. Kimber 'Works Organisation', *Proceedings of the Institution of Automobile Engineers*, 11 (1916–17), 396, quoted by Lewchuck, *American technology*, p. 159.
19 Tolliday and Zeitlin, *The Automobile Industry*, p. 36.
20 Tolliday and Zeitlin, *The Automobile Industry*, p. 34.
21 Tolliday and Zeitlin, *The Automobile Industry*, p. 37.
22 Lewchuck, *American technology*, pp. 163–7.
23 Quoted by Lewchuck, *American technology*, p. 166.
24 Lewchuck, *American technology*, pp. 120–30.
25 Lewchuck, *American technology*, p. 121.
26 Much of the following is based on Lewchuck, *American technology*, pp. 167–70.
27 James Laux, 'The Genesis of the Automobile Revolution', in Bardou *et al., The Automobile Revolution*, p. 71.
28 According to Tolliday and Zeitlin, *The Automobile Industry*, pp. 37–8, a crude hand-

powered assembly line was in place by 1914 and the line was mechanised in late 1933.

29 Tolliday and Zeitlin, *The Automobile Industry*, p. 38.
30 W. R. Morris (Lord Nuffield), 'Policies that have built the Morris Business', *Journal of Industrial Economics* (1954), 195, quoted by Tolliday and Zeitlin, *The Automobile Industry*, p. 29.
31 Lewchuck, *American technology*, pp. 169–70.
32 Lewchuck, *American technology*, pp. 170–8.
33 'Third Annual Meeting of the Institute of Production Engineers', *Proceedings Institute of Production Engineers* (1924–25), 7, quoted by Lewchuck, *American technology*, p. 172.
34 C. R. F. Engelbach, 'Presidential Address', *Proceedings of the Institution of Automobile Engineers*, 28 (London, 1933–34), 7, quoted by Tolliday and Zeitlin, *The Automobile Industry*, p. 39.
35 The following material about France is based largely on Sylvie Van de Casteele-Schweitzer, 'Management and Labour in France 1914–1939', in Tolliday and Zeitlin, *The Automobile Industry*, pp. 57–75.
36 Bardou *et al.*, *The Automobile Revolution*, pp. 81 and 103; Berliet had assembly lines throughout his factory by 1920.
37 Patrick Fridenson, 'American dominance 1918–1929', in Bardou, *et al.*, *The Automobile Revolution*, p. 103.
38 Fridenson, 'American dominance', p. 106.
39 James M. Laux, 'An expanding market and production innovations, 1908–1914', in Bardou *et al.*, *The Automobile Revolution*, p. 73.
40 Penny Sparke, *Italian design, 1870 to the present* (London, 1988), pp. 34–5; on p. 36, Sparke gives the date of a prototype as 1911.
41 Lanx, 'Expanding market', p. 63.
42 Duccio Bigazzi, 'Management strategies in the Italian car industry 1906–45: Fiat and Alfa Romeo', in Tolliday and Zeitlin, *The Automobile Industry*, p. 85.
43 Fridenson, 'American dominance', pp. 103–4.
44 Van de Casteele-Schweitzer, 'Management and Labour in France', p. 61.
45 Van de Casteele-Schweitzer, 'Management and Labour in France', p. 60.
46 Patrick Fridenson, 'Difficult years', in Bardou *et al.*, *The Automobile Revolution*, p. 147.
47 Bigazzi, 'Management strategies', p. 86.
48 Fridenson, 'Difficult years', p. 145.
49 Patrick Fridenson, 'Total war', in Bardou *et al.*, *The Automobile Revolution*, pp. 159–67.
50 Fridenson, 'Total war', p. 166.
51 Penny Sparke, *Japanese Design* (London, 1987), pp. 66–79; Giuseppe Volpato, 'The Automobile Industry in Transition: Product Market Changes and Firm Strategies in the 1970s and 1980s', in Tolliday and Zeitlin, *The Automobile Industry*, pp. 193–223; *Nippon: Japan since 1945*, 'Taking on Detroit', BBC 2, 18 Nov. 1990.
52 Quoted in *Nippon*, BBC 2, 18 Nov. 1990.
53 Volpato, 'The Automobile Industry in Transition', p. 200.
54 Donald Frey, interviwed in *Nippon*, BBC 2, 18 Nov. 1990.
55 Thomas Hine, *Populuxe* (London, 1987), p. 84; much of the following is drawn from pp. 83–106. See also, Stephen Bayley, *Harley Earl* (London, 1990).

56 Lewchuck, *American technology*, p. 186.
57 Volpato, 'The Automobile Industry in Transition', p. 197.
58 Quoted by Hine from advertising copy put out by American Motors, who made 'compacts', *Populuxe*, p. 106.
59 Hine, *Populuxe*, p. 106.
60 *Nippon*, BBC 2, 18 Nov. 1990.
61 Sparke, *Italian Design*, p. 208.
62 Volpato, 'The Automobile Industry in Transition', p. 218.

Part II

Modernism and the mass production of myth

4 Believers, heretics and innocents

Following the emergence of mass production at the beginning of the present century, there has been much speculation about its technical, social, political and aesthetic consequences. In these discussions – at whatever level they have been or are conducted – mass production is credited with a range of abstract qualities. Its importance in the history of production technology is considerable; but in the wider world it is seen as one of the key ideas of the twentieth century, which has fundamentally altered the texture of Western life. The arts – music, literature, theatre, painting, sculpture, architecture and design – have all been affected. Both as abstract ideas and as technological reality mass production has had consequences for design; but in terms of the forms that manufactured objects take, the consequences arising from abstract ideas have been the more profound. In identifying how these ideas have affected form, the perceptions of three groups of people are of particular importance: firstly, those artists, designers, architects and critics engaged in the 'high debate' of architecture and design; secondly, manufacturers and their agents – such as designers and retailers – through whom they act; and thirdly, consumers, or the 'mass' implied in the phrase 'mass production'. Their differing, but intertwined perceptions of mass production and of one another have helped to shape the forms of manufactured objects.

The term 'mass production' was brought into the mainstream of the English language by Ford, or at least Ford's office, in the mid 1920s.[1] Once in the world, it rapidly shed its fairly precise meaning of assembly line production as Ford practised it, for something more emotive, more elastic, more ideal and more useful. The essential ingredient in all abstract concepts of mass production is invariably the replication in quantity of the artefact; standardisation is implicit and mechanisation usually taken for granted. All else is optional. Thus, the factory, the division of labour, single-purpose machinery, 'flow production', the assembly line, the complexity or simplicity of the product, the economy of production, high

This 'Chamber suite' was offered by the Phoenix Furniture Company in 1878.
A number of furniture-makers, clustered around Grand Rapids in Michigan,
produced simple, machine-made forms, enriched and differentiated by the use
of glued-on, ornamental components.

wages and low prices may be severally added, each bringing the term
closer to its earlier technical and economic definition. But for the most
part, the utility of the looser concept was that it became a shorthand for
describing all forms of mechanised serial production. In this sense, mass
production was identified as a phenomenon pre-dating Ford's experiments
at Highland Park. Siegfried Giedion, writing some twenty years after the
term first appears, identifies the mass production of cloth in eighteenth-
century England, or, in the next century, the mass production of 'apples,
peaches, corn, tomatoes, cows, pigs, eggs, or poultry' by American farmers.[2]

As an idea, mass production was seen to embody a whole range of
preoccupations central to the Modern perspective. It could be cited as a
distillation of the machine as producer and as form-giver. The broad

hostility exhibited towards the machine as a means of production by the British Arts and Crafts movement was gradually eroded, especially when the issues raised were taken up in Germany and America.

In Germany, many of the *Werstätte*, whose outlook had been based on the concerns of the British Arts and Crafts movement, produced luxury goods for a design-conscious middle class with the use of machinery; the artist designer, rather than the capitalist, was in control of the means of production. More ambiguously, Peter Behrens put his artistic talents at the disposal of the electrical conglomerate AEG, sharing with the critic Hermann Muthesius a belief that the artist designer had a profound duty to supervise and encourage the production of sober, machine-made forms which would, in turn, foster a stable, orderly society sharing common values.[3] Meanwhile, Frank Lloyd Wright in America and W. R. Lethaby in Britain sought accommodation between the machine and the values of the Arts and Crafts Movement. According to these values, there was to be no deceit about materials or structure; and just as Ruskin had celebrated the ways in which craft techniques revealed human nature in their imperfections, in this new climate, machine-made objects were to be similarly candid about the mechanical nature of their origins.

On an aesthetic level, the standardisation which it was believed mass production demanded, was welcomed by Modernists. Not only did it imply system, order and rationality at a time of perplexingly rapid change, it seemed also to offer a viable alternative to aesthetic values rooted in historicism. It could provide an authentic expression of the technological nature of contemporary life as well as a formal harmony and resonance which, hitherto, the machine and industry had been guilty of destroying. Further, coinciding with yet another Modern preoccupation, the formal values derived from the technical demands of mass production were thought to favour the abstract and therefore the universal, rather than the literal, the associational and the particular. If Modernism was to become international or even supranational, as its advocates claimed it inevitably would, universality was essential.

The demands of industrial production and function could refine and simplify forms in a manner analogous to biological evolution. Forms so refined, it was claimed, constituted design 'types' or norms. Muthesius expounded his theory of 'type-forms' in the context of the *Deutsche Werkbund*. Similarly, the forms of banal objects such as wine bottles, glass tumblers, pipes and guitars were celebrated in the abstract, geometric Purist paintings of Amédée Ozenfant and Le Corbusier. The latter

Modernism and the mass production of myth

Electric kettles designed by Peter Behrens for AEG, 1909. From a limited, but interchangeable range of basic, machine-made components capable of various finishes, eighty-one different designs could have been offered to the public, though only thirty were marketed. This pattern of designing for variety rather than uniformity has been widely emulated.

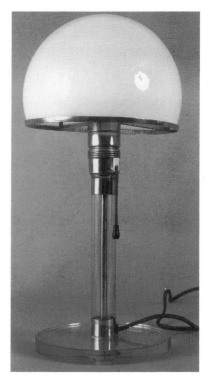

A table lamp designed by K. J. Jucker and Wilhelm Wagenfeld, 1923–24. Mass production was to be the means by which 'good form' was to be made available to the masses. The lamp was intended by its designers as an industrial prototype, but when approached, manufacturers laughed at it. Its aesthetics spoke of the Machine, but it was wholly unsuited to industrial manufacture.

chose Thonet bentwood chairs to furnish the pavilion of L'Esprit Nouveau at the Paris Exhibition of 1925. Giedion explains: 'Standardization and mass production [of Thonet furniture] began in the early [eighteen] fifties . . . and were never discontinued. When the architect could no longer endure the *art decoratif* furniture, these simple beechwood chairs offered what they were seeking: form purified by serial production.'[4]

The anonymity of these chosen designs was to be celebrated; the designs were the result of impersonal, almost 'natural' forces.

The Modern Movement retained and developed the argument of the Arts and Crafts Movement, that the nature of the designed environment could affect the morals, happiness and well-being of the masses; whereas, in its enthusiasm for the machine as an abstract, the idea of the masses as workers, degraded by factory conditions, seems to have slipped progressively lower on its agenda, to be taken up by commentators and critics in spheres other than design. To this extent, the masses were made to resemble the high debaters' own lives more closely. Mass production,

Pavilion of L'Esprit Nouveau, interior, Paris Exposition, 1925. Convenience in use and the demands of mass production, the argument ran, had refined and ennobled the forms of the wine bottles, tumblers or pipes coolly abstracted in the Purist paintings, as well as the Thonet furniture asembled for this didactic exhibit. A questionable naturalness was ascribed to this 'evolutionary' process.

it was argued, if properly guided and controlled could provide the means by which the machine might resolve, rather than aggravate social ills. Could not this apparently miraculous agent supply standardised products – in this case, virtually the whole of the material environment, including buildings – cheaply and in great quantity for the masses, where material wants were all too real and painful to liberal sensibilities? And might this not have beneficial spiritual consequences? Serge Chermayeff spoke for many when, in 1933, he pleaded:

> If we were to employ immediately and intelligently the materials and methods of our machine age, to supply the physical and economic needs of humanity, we would release a society of sane individuals. If [the] benefits of technical developments could be broadcast to raise the general *standard of living* we should have less *standardised thinking* ... A sense of physical and economic well-being would make the mass of released individuals more sensitive to the graces of life.[5]

Mass production was to be the means by which an increasingly mechanised society might supply itself with products whose designs were authentic expressions of itself. As Paul Greenhalgh remarks,

> The over-arching concern of the Modern Movement was to break down barriers between aesthetics, technics and society, in order that an appropriate design of the highest visual and practical quality could be produced for the mass of the population ... Mass production and prefabrication were embraced as the means by which Modernism would arrive on the streets.[6]

In the West, mass production held out the prospect of resolving material, social, political and spiritual ills in a liberal, capitalist context, of alleviating the alienation of the proletariat without the inconvenience of full-blown Bolshevism. It is not without irony that in post-revolutionary Russia, leading artists, architects and critics held the methods of Frederick Taylor, mass production and Henry Ford in high esteem. Indeed there was an enthusiasm for all things American – including Charlie Chaplin and Mary Pickford – since America was seen as a Modern, technologically advanced and revolutionary nation. These princes of capitalism were celebrated for their revolutionary approaches to the means of production. Given the tumultuous material, social, political and economic difficulties facing the Soviet Union, the economies and material bounty promised by mass production were attractive in their own right. But beyond this, it

provided intellectuals with a potent symbol of the rational, the Modern, the progressive and the technological, entirely congruent with the aspirations of the political experiment in hand. Meyerhold, for example, developed 'biomechanics', a style of mechanistic, 'Taylorist', impersonal acting, first put before the public in *The Magnanimous Cuckold* in 1922, with abstract machine sets devised by Luibov Popova. The Constructivist theorist, architect and critic, Moisei Ginzberg, quoted at length from *My Life and Work* after its appearance in Russian in 1924.[7] Ford had written glowingly of the successful application of his principles of analysis to the organisation, not only of his factories, but of a hospital as well. Perhaps all architectural problems might be susceptible to this type of analysis, once due weight was given to the social dimensions of architectural and design problem-solving.

From this perspective, functionalism is the mirror of mass production. Ginzberg was only one among many in the Modern Movement who thought that the underlying principles, the apparent rationality and the analytical methods behind mass production applied equally to design. Like manufacture, design might also be seen primarily as a problem-solving activity, even when some of the problems were social, cultural and aesthetic.

At the Bauhaus, the task of reconciling art, technology and social responsibility lay at the centre of most of its intense history. Once relative political and economic stability encouraged an engagement with the industrial world outside, the emphasis switched from craft practice as a means of production to the workshop as research laboratory, where prototypes for industrial manufacture might be developed. The gaps between craft and industry, as well as between mass production as polemic and as reality, were not easily bridged. The elegant lamp designed by Karl Jucker and Wilhelm Wagenfeld in 1923–24, for example, was seriously intended for inexpensive industrial manufacture. Yet it belonged, in part, to the same realm of Platonic abstraction as Marianne Brandt's celebrated tea infuser: severe geometric forms spoke poetically of the precision of the machine, while the design itself was not easily realised by industrial means. 'Retailers and manufacturers laughed at our efforts', recalled Wagenfeld. 'These designs which looked as if they could be made inexpensively by machine techniques were, in fact, extremely costly craft designs.'[8] Marcel Breuer's experiments with tubular steel furniture went somewhat further. They were a brave attempt to reconcile a whole range of aesthetic, spatial and social issues, and proved suited to commercial manufacture. They utilised a standardised industrial product – steel tubing

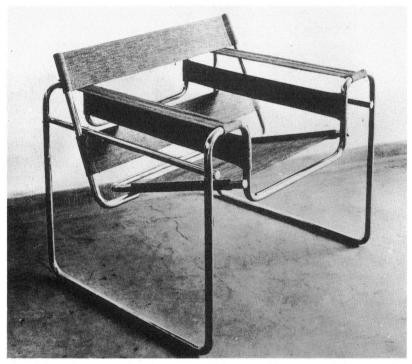

Armchair designed by Marcel Breuer, 1925. A notable commercial success for
the Bauhaus, nearly all the techniques required for its manufacture were
simple craft-like operations. By contrast, its design seemed expressive of the
most Modern, sophisticated machine aesthetics.

– to great effect. Yet, however expressive of the idea of machine produc-
tion the designs may have been, the sequence of pipe-bending, welding,
chromium plating and sewing required a co-ordination of craft skills,
rather than the high levels of mechanisation implicit in the idea of mass
production.[9] Wagenfeld, Brandt and Christian Dell all eventually suc-
ceeded in making the shift from craft production to industrial prototype,
most notably in the area of light-fittings.

The dehumanising character of factory labour had been a central con-
cern of William Morris, and as a curious, distant echo it informed some
attitudes towards industry at the Bauhaus. Looking back in 1938, Marianne
Brandt, for example, recalled that when installing the up-to-date manufac-
turing machinery in a laboratory/workshop at Dessau, they aimed to cre-
ate 'a functional but aesthetic assembly line, small facilities for garbage

disposal, and so forth,' adding that in retrospect these 'seem to me no longer prerequisite for a first-class lamp'.[10] But in his writings in 1947, the year Ford died, Laszlo Moholy-Nagy felt the designer had genuine responsibilities to the assembly line worker:

> the Taylor system, the conveyor belt, and the like, remain misinterpreted as long as they turn man into a machine . . . He [the designer] should make his design with the aim of eliminating fatigue from the worker's life. He must see the design through, not only in the technical, but in its human effects as well. This quality of design is dependent not alone on function, science and technological processes, but also on social consciousness.[11]

Ford, the manufacturer and polemicist, had claimed that high wages and a clean factory would keep workers broadly content. Morris, the design reformer, came to believe that direct involvement in politics, rather than the activity of designing, was more likely to be an effective means of altering the lot of working people.

The enthusiasm with which the Modern Movement took to mass production was accompanied by reservations and ambivalence. As in earlier centuries, nature was often invoked as a remedial authority. In this case, it was useful in countering criticisms that the Modern approach to design was excessively mechanistic. Belief that mass production played a part in the 'evolution' of form has already been noted. Moholy was not alone in admiring Raoul H. Francé's *Die Pflänze als Erfinder (Plants as Inventors)*, published in 1920, which drew parallels between the evolution of natural and technological forms. In each case, efficient forms originated in function. Frank Lloyd Wright was another who sought to reconcile nature and technology through his somewhat fugitive concept of 'Organic Architecture'. If Modernism was regarded as natural, it would, like other natural forces, also be authentic and inevitable; logically, everything else was unnatural, inauthentic and doomed. In one of his Utopian schemes, Broadacre City of 1936, Wright asserted that the technological forces of the car, the radio, the telephone and, more than anything else, standardised machine shop production, would inevitably give shape to the city of the future. Yet, as its name implies, this 'city' was to be semi-rural, the technologies of improved communication meant that homes need no longer be crowded together as in the cities of the past. Here, every man was to be given an acre of land at birth to grow his own food. These lucky smallholders would work part-time at rural factories, to which they might

drive in second-hand Model Ts. Clearly, whatever Wright's appreciation of the consequences of mass production, he shared with Henry Ford a nostalgic, somewhat reactionary enthusiasm for the lost American idyll. Once again, mass production and technology were to be the tools by which alienation might be remedied and the idyll recovered.[12]

The means of production – including mass production – were controlled by manufacturers who principally wanted design, insofar as it was deemed necessary at all, to secure the best returns on their investments. As Ford had demonstrated, it mattered little how efficient or economical the making of a product might be in terms of use of materials, manufacturing processes and energy consumption, returns on money invested could only be secured if the product found favour with the buying public. The example of General Motors' introduction of programmed styling changes to stimulate demand was followed only gradually by manufacturers of other product-types and in other countries. Unlike General Motors, few manufacturers in America had direct contact with their buying public.[13] Their goods were sold to retailers, and in the 1920s it was American retailers who increasingly saw novelty and the perception of change as marketing tools. Similarly, that this process might be better understood and managed, the skills of market research first emerged among the large stores, rather than manufacturers. Gradually, competition led manufacturers first to embrace colour changes in their goods – following the example set in the car industry – and then to adopt programmes of planned restyling to make their products distinctive from those of their competitors. While the Depression initially caused this process to falter, it was ultimately responsible for its acceleration, as those manufacturers who survived competed more fiercely with one another. Market research and the services of professional industrial designers were key factors in this struggle.

If functionalism was the mirror image of the Modern Movement's perception of mass production, then industrial design was, in part, sold to American manufacturers as a rational response to their particular understanding of what mass production was about. To the mechanistic analyses of Taylorism had recently been added the refinement of the industrial psychologist, whose task was to understand the motivation of workers and thereby secure increases in productivity. The machinery of distribution had become highly developed in the 1920s, with national advertising campaigns, consumer credit and Modern chain stores; but just as the

industrial psychologist had been able to 'lubricate' the production mechanism, so the 'consumer engineer', or designer, might eliminate 'the obstacles in the way of the free flow of goods from factories to consumers.'[14] Thus, by applying the conceptual tools of mass production to mass distribution, the production-consumption process – then exhibiting signs of distress and disorder – was to be reworked into one continuous, streamlined flow.

The early American industrial designers drew on the high debate for a substantial part of their rhetoric, rationale and a limited range of formal qualities. They turned to architecture, rather than the traditions of American designers, who were rooted in a craft-orientated conservatism. Most of the industrial designers were drawn from the ranks of advertising men, retail or theatre designers – all branches of commerce dependent on tapping successfully into the emotions. Attitudes towards Modernism and machine aesthetics in architecture were greatly informed by the thoughts and works of Le Corbusier, whose *Towards a New Architecture* appeared in English in 1927, and Erich Mendelsohn, whose exhibited drawings, and sketches, as well as photographs and models of his work, attracted attention in 1929.[15] Insofar as either expressed a machine aesthetic from which designers might draw, visually it was romantic and expressionistic. These commercial men were well aware that their task was to stimulate consumption, but there was a tendency to legitimise their activities at a higher, moral level, by claiming that the beauty of well-designed, mass-produced objects would raise public tastes and, in the words of the advertising executive, Earnest Elmo Calkins, relieve 'the ugliness and spiritual poverty of much of this Modern machine environment.'[16]

When the American industrial designers evolved a machine aesthetic for mass-produced products – streamlining – they deliberately chose an emotive version of the machine, which represented it as dynamic and, to a degree, organic. Machine production may be implicit in the precision of any machine aesthetic, but the explicit references in streamlining are to machines of transportation – to machines of use, rather than production. Perhaps the advantages of the machine as mass production were judged too abstract, too remote to be intelligible and too collective from the consumer's perspective; or perhaps, too intelligible. What *do* you tell a factory worker about the machine, when you want his or her money? The appeal, the exhilaration of the effortless speed of the motor car and the swooping airplane, on the other hand, were immediate and, potentially at least, personal.

Modernism and the mass production of myth

Not everyone approved of their efforts. Published in 1934 – when the industrial designers were beginning to get into their stride after the slump – *Technics and Civilization* was Lewis Mumford's passionate, ground-breaking and occasionally idiosyncratic analysis of the role of technology and the machine in human culture. Mumford allied himself more closely to European Modern Movement sensibilities than to the intellectual or material fruits of native American commercial imperatives. He approved of Le Corbusier's elevation of mass produced, commonplace objects,[17] but complained: 'The frantic attempts that have been made in America by advertising agencies and "designers" to stylicize machine made objects have been, for the most part, attempts to pervert the machine process in the interests of caste and pecuniary distinction.' According to Mumford, 'The real social distinction of Modern technics ... is that it tends to eliminate social distinctions.'[18]

The high Modern attitude towards design was habitually ascribed an

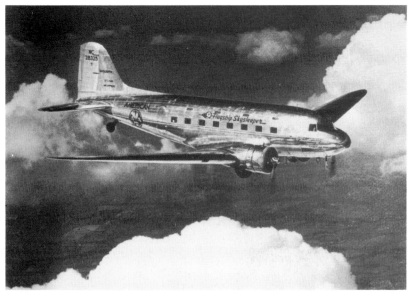

Learning from aircraft: Douglas DC-3, 1936. Streamlining in design was a readily intelligible machine aesthetic which drew on and informed the designs of cars, boats and aeroplanes. High European Modernism made oblique references to the anonymous machine as producer and form-giver, but streamline modern referred directly to machines of movement and personal exhilaration.

unimpeachable legitimacy and authenticity. To achieve this, it was necessary for Modernists to hold up to their audiences the alternatives, with unsparing descriptions of the dire consequences which these would bring in their wake; and, as noted earlier, Modernism, which expressly celebrated the technological, had to be made 'natural'. Mechanical replication in all fields challenges the notion of authenticity. Walter Benjamin in *The Work of Art in the Age of Mechanical Reproduction*[19] had argued that the uniqueness of the actual presence of a work of art, which he described as the 'aura', was compromised when mechanical reproductions – photographs, prints, x-rays, films – were in circulation. Perceptions were not as they had been; the work of art was altered. Mechanical reproduction, he believed, by destroying the authenticity of an object, transformed the very nature of art.

Nor were these concerns confined to the rarefied provinces of art historians. Set in London some thousands of years hence, Aldous Huxley's *Brave New World* described a society where Fordism and the evils

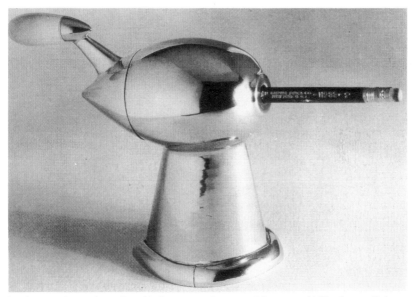

Stationary dynamism. Pencil sharpener, Raymond Loewy, 1933. Streamlining was by no means confined to things which *actually moved*. It became associated with the architecture of popular pleasure – movie houses and diners – as well as lending an easily recognisable dynamic modernity to otherwise banal products of this sort.

105

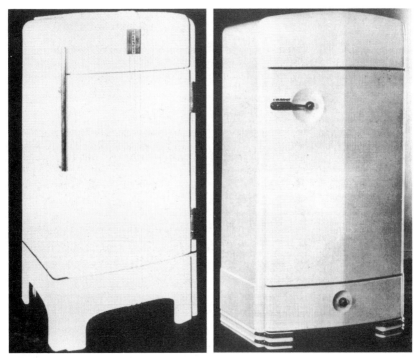

Learning from motor cars. The Coldspot refrigerator for Sears, Raymond
Loewy, 1935 and 1938. The Coldspot not only borrows from the
manufacturing technology and imagery of automobiles – pressed metal panels,
chrome trim – but, like cars, was restyled each year. Rather than the stable
'type forms' central to much Modern thinking, capitalism fostered the
appearance of change.

believed to accompany it had developed into a world of terrifying order,
apparent stability and loss of individual identity. Human eggs are repli-
cated or 'bokanovskified' eight to ninety-six times before incubation and
modification on a moving assembly line at the 'Central London Hatchery
and Incubating Centre'. Human beings are turned out in grades from
Alpha down to Epsilon. The Director is showing some students the plant:

> Standard men and women; in uniform batches. The whole of a small factory
> staffed by the products of a single bokanovskified egg.
>
> 'Ninety-six identical twins working ninety-six identical machines!' The voice
> was almost tremulous with enthusiasm. 'You really know where you are. For
> the first time in history.' He quoted the planetary motto. 'Community, Identity,

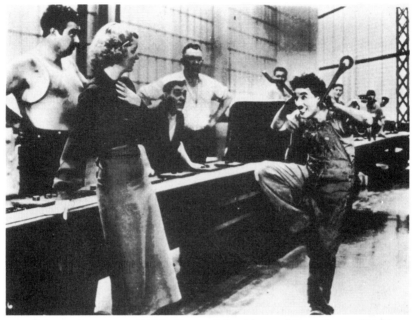

Chaplin's *Modern Times* (1936). Fears of the dehumanising effects of highly mechanised production techniques on factory workers were widely expressed. Fritz Lang's *Metropolis* (1926) and René Clair's *A nous la liberté* (1931) both addressed the issue, while in Chaplin's case, repetitive assembly line work drives the Little Tramp mad.

Stability.' Grand Words. 'If [only] we could bokanovskify indefinitely ... standard Gammas, unvarying Deltas, uniform Epsilons. Millions of identical twins. The principle of mass production at last applied to Biology.[20]

In the popular sphere, reservations about work on the assembly line were given dramatic and comic focus in Charlie Chaplin's film *Modern Times*, released in 1936. In it, Chaplin as the Little Tramp works on an assembly line, tightening a bolt over and over again on some unidentifiable product. The line is increasingly speeded up and eventually Chaplin snaps. His body starts to twitch uncontrollably in the manner of his nut-tightening exercise. In one famous scene, he seems entrapped and about to be consumed by some giant machine. Like René Clair's earlier 1931 work, *A nous la liberté* – to which *Modern Times* owes a debt – the film served to express and codify an increasingly widely held view of the

consequences for those who worked in mass production: those who tend the machines become like the machines; they lose part of their humanity.

Yet for many in the Modern Movement, the possibility that technology, including mass production – the technology of replication – could transform consciousness was viewed with enthusiasm rather than despair.[21] Mumford was quite clear about the direction in which technics would inevitably drive design:

> The machine devaluates rarity: instead of producing a single, unique object, it is capable of producing a million others just as good as the master model from which the rest are made. The machine devaluates age: for age is another token of rarity, and the machine, by placing its emphasis on fitness and adaption, prides itself on the brand-new rather than the antique: instead of feeling comfortably authentic in the midst of rust, dust, cobwebs, shaky parts, it prides itself on the opposite qualities – slickness, smoothness, gloss, cleanliness. The machine devaluates the archaic taste: for taste in the bourgeois sense is merely another name for pecuniary reputability, and against that standard the machine sets up standards of function and fitness. The newest, the cheapest, the commonest objects may, from the standpoint of pure esthetics, be immensely superior to the rarest, the most expensive, and the most antique. To say all this is merely to emphasize that the Modern technics, by its own essential nature, imposes a great purification of esthetics: that is, it strips off all the barnacles of association, all the sentimental and pecuniary values which have nothing whatever to do with esthetic form, and it focuses attention on the object itself.[22]

Mumford spoke for many in the Modern Movement when he made his elegant, confident predictions. Yet in their devout faith in the authenticity, the final, universal reality of their vision, they found it impossible to acknowledge that the 'masses' shared much of that vision, and looked on it with gloom and foreboding. It 'is capable of producing a million others just as good as the master model from which the rest are made,' crows Mumford. From Mary Shelley's *Frankenstein* to Fritz Lang's *Metropolis* to *Invasion of the Body Snatchers*, *Bladerunner* and beyond, the fear that has haunted the triumphs of science, mechanisation, industrialisation and mechanical replication is the fear that the natural or rather, habitual authenticities of our existences will be replaced with something less valuable, synthetic, inauthentic, until the human being becomes uniform, mechanised and dead. These dangers were cited in debates elsewhere concerning the effects of the assembly line on workers. They were seldom addressed with sufficient vigour by the theorists of the Modern Movement. For

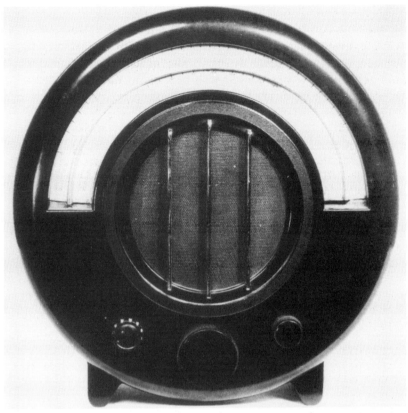

Ekco radio designed by Wells Coates, 1934. Designs like this seemed proof to some Modern critics that simple forms which expressed their machine origins were more beautiful, more natural, more moral and socially less divisive than their historicist or 'Jazz-Moderne' equivalents. In practice, the public – the 'mass' implicit in mass production – bought and presumably enjoyed a whole range of products at odds with such strictures.

them, authentic, Modern reality was something which would be achieved when the 'barnacles of association' had long since been scattered. Yet the masses, in whose name the crusade was being undertaken, wanted, needed, used and enjoyed barnacles.

All around, Modernist critics identified evidence of the 'truth' of their observations. Pevsner pointed to the commercial successes of new bakelite radio cabinet designs by Serge Chermayeff and Wells Coates for E. K. Cole Ltd. To mould bakelite on this scale required that the moulds be

milled from solid chromium steel. The process demands that the mould should have no undercuts – details which might make the mould more complex and prohibit extraction of the finished cabinet. These designs reflected and exploited that technological fact in their simple, precise forms. Similarly, E. Maxwell Fry admired an office desk made from sheet steel. 'Cellulose paint and the new machinery that presses thin sheets of steel into rigid motor-car bodies [make this] desk . . . both practical and beautiful. It is brilliant vermilion, and could be any other cheerful colour.'[23]

Gradually, the distance between the Modernism of the lofty abstract visionaries and the Modernism of commerce, manufacture and popular taste became clearer: high Modernism sought, eventually, to transform the world, while commercial Modernism provided an immediate, fantastic escape from it. There was some overlap between high and popular perceptions. However much some critics despised them, the smooth forms of streamlining provided an intelligible image of technological sophistication and harmony. Similarly, this vision of the future, where science and technology were to inform design, implied a more rationally ordered, more egalitarian society – an attractive idea, not only to Mumford and the Moderns, but to all Americans who already hoped they had left the Old World social order behind, as well as to Europeans, eyeing the American Dream with keen interest through Hollywood's spectacles. Through design, through streamlining, ordinary people might enjoy the illusion of being a part of it, provided – as when they accepted the warm embrace of the cinema – they were willing to suspend their disbelief. In architecture, streamlined Modernism became, more than anything else, the architecture of leisure, of the movie houses, the swimming pools and the diners, of the pictures, the lidos and the chip shops.

In theory, mass production was going to be a source of material plenty and the starting point for a new, authentic reality; in practice, the masses chose illusion. 'Practically all cheap, mass produced furniture is . . . "Modernistic" ', railed Pevsner.[24] With few exceptions, the sofa-buying masses left the cool abstractions of high Modernism to the wealthy, the educated and the corporate, while the actual machinery of mass production was being used to supply their preferred commodities of the imagination. Streamlining was one such fiction; 'Modernistic' another. If you did not like either of them, you could select from a whole range of others, principally costume dramas. For like that other, more obvious agency for the mechanised serial production of fictions, the cinema, where one could

choose between *Things to Come* or *Elizabeth and Essex*, mass production could be employed to cater for many tastes. This was to prove the irreconcilable problem.

Inherent in most Modernist attitudes towards design, there has been a paradox. On the one hand, there is a strong, collective moral and social thread, which argues that Modernism is desirable because it will liberate and thus redeem the masses. Yet, from Morris onwards, there is an almost unmitigated horror of the vulgar. Implicit in the programmes of the Modern Movement is a desire to stop the masses being vulgar. It was seldom expressed in those terms. Vulgarity, after all, could be displayed by the rich, the bourgeois and the philistine or could be blamed on capitalist exploitation, avarice and short-sightedness. The masses were not 'naturally' vulgar. They might exhibit vulgar taste, but that was cited as yet further evidence of the 'unnatural' state to which they had fallen and gave added urgency to the plea for Modernism to be pursued with vigour, that the masses – and everyone else, for that matter – might savour its promised harmonies.

Tacitly, the masses were feared. In some ways, the high Modernists were like anxious, liberal aristocrats. They could see that revolutionary democratic machinery – mass production – was being constructed and, in principle, welcomed it. They loved the 'masses' and owed them a debt of responsibility by virtue of their own superior intellects. At the same time, they were anxious that the masses – newly enfranchised and unaccustomed to the exercise of power over the material dimensions of their imaginations – might choose products and ideas with which they were out of sympathy, which might, indeed, threaten their habitual prerogatives. Looked at from different perspectives, the mass is the majority, in whose name action in a democratic society is taken; or the mob, whose irresponsibility threatens.[25] While Modernism was being built – ostensibly – to benefit the masses, its orthodoxies were constructed, in part, as a weapon to fight the onset of chaos, which mass production might otherwise deliver. Modernism was to be the sole, rational basis on which the material world might be re-made and the infallible screen by which the bad and the ugly were to be separated from the good and the true. It might also separate the inauthentic from the authentic. In this capacity, the aristocrats doubled as priests, duty bound to pontificate.

'I must admit that my main interest was with design in mass production,' announces Pevsner in the opening pages of *An Enquiry into Industrial Art*

in England, published in 1937. He was doing no more than repeating well-worn orthodoxies when he asserted that

> a cardboard travelling case made to imitate alligator skin . . . a bakelite hair-brush made to imitate enamel . . . a pressed glass bowl trying to look like crystal, a machine-made coal-scuttle trying to look like hand-beaten, machine-made mouldings on furniture, a tricky device to make an electric fire look like a flickering coke fire, a metal bedstead masquerading as wood – all that is immoral.[26]

Without making a facile equation of Modernity with beauty, Pevsner, the devoutest of Modernists, estimated that 90 per cent of national output was 'devoid of any aesthetic merit'.[27] In general, it is clear from his writings that this 90 per cent included virtually everything which was 'Modernistic' or historicist in derivation. In differing proportions and with regional variations in the products on offer, similar pictures were discernible to Modernists elsewhere in Europe, as well as in America. When the masses chose their material fictions – as the wealthy and powerful had done for centuries past – and they were not the Modern fictions which the Modernists had expressly constructed for the benefit of the whole of human kind, the priests grew censorious:

> A splendour which reality does not concede is brought into our humble surroundings by meretricious industrial products, which achieve in permanence some of the elating effect that for a few hours is bestowed upon us by the Hollywood heroes' fantastic mode of life in the pictures. The pleasure which most people take in an entertainment so vicarious as the cinema, as well as the pleasure in vulgar boastful design, is largely accounted for by the universal and irresistible longing for escape.[28]

The cinema, like mass production, was a means by which the machine could replicate fictions and bring them to the masses. Like the novel before it, and radio, television, video and, most recently, computer generated 'virtual reality' after, the cinema was regularly condemned as decadent. Pevsner was not alone in believing that both mass production and the cinema provided evidence of aesthetic and moral wrong-doing as well as inauthenticity. Huxley's 'feelies' in *Brave New World* – where audiences could themselves 'feel' the tactile aspects of erotic performances depicted on the screen – were but one extreme. Mumford was equally censorious: 'The moving picture deliberately glorifies the cold

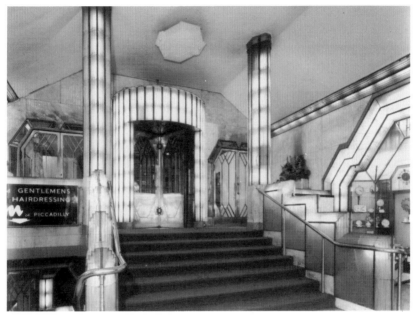

The Strand Palace Hotel, London, 1929–30, by Oliver Bernard. A flashy, exuberant, glamorous machine aesthetic intended to woo and flatter the popular end of the market. Popular modernism and the streamlining which soon followed were seldom wholly approved of by the Modern Movement, which, though dedicated to the salvation of the masses, was rarely comfortable with vulgarity.

brutality and homicidal lusts of gangsterdom', he wrote, arguing that these fictions would be but rehearsals for brutality in real life. 'In the act of relieving psychological strain these various devices only increase the final tension and support more disastrous forms of release.'[29] He admired *Nanook of the North, The SS. Potemkin* and newsreels because they dealt with immediate experiences rooted in objective reality and were therefore authentic. Strangely, he allowed some merit to Chaplin, René Clair and Walt Disney because of their ability to deal with 'the inner realm of fantasy' and yet condemned all attempts at story-telling.[30] As in design and architecture, so in film, the machine must be used for the purposes of abstraction and universality rather than overt, specific representation.

Mumford was also hostile towards 'mass sport', which had become a spectacle, the enjoyment of which echoed the 'vicarious' nature of the cinema.[31] Watching was inferior to doing, he argued, conveniently

Modernism and the mass production of myth

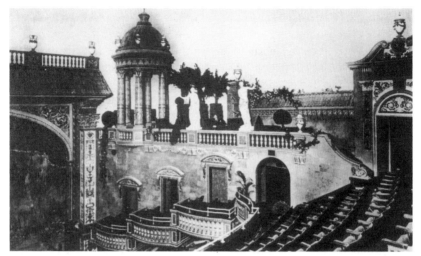

Majestic (movie) Theater, Houston Texas, 1923. Modern critics such as Lewis Mumford and Nikolaus Pevsner thought they had identified the technological 'reality' of the present. Accordingly, they derided all forms of 'mass escape', including not only popular cinema, but all design which failed to express this 'truth'. It was the machine itself which made the dissemination of these fictions possible.

neglecting the fact that, unless attempted simultaneously, these are not by their nature mutually exclusive. Similarly, he condemned the taking of a gramophone on a picnic, on the grounds that listening to it was inauthentic compared with the activity of singing, which he praises on several occasions.[32] Mumford may have thought dancing to the gramophone authentic, but this is unlikely, given his hostility towards yet another popular form – jazz. Noting that the interest of painters such as Picasso and Braque in African artefacts coincided with an interest in the machine, Mumford observed, 'Congo maintained the balance against the motor works and the subway.'

> But on the wider platform of personal behaviour, the primitive disclosed itself during the twentieth century in the insurgence of sex. The erotic dances of the Polynesians, the erotic music of African negro tribes, these captured the imagination and . . . reached their swiftest development in the United States, the country that had most insistently fostered mechanical gadgets and mechanical routines. To the once dominantly male relaxation of drunkenness was added the hetero-sexual relaxation of the dance and the erotic embrace, two phases of the sexual act that were now performed in public.[33]

Authentic Modernism, predicated on the extent to which it excluded, was probably white, male and uneasy with sexuality. Many Modernists addressed the emotive, sensuous aspects of experience and the possibilities that these opened up in terms of Modern architecture and design. But only certain forms were licensed. Others were regularly rejected as anti-rational, barbaric and as representing a retreat to the 'primitive': hence, Mumford railing against 'perversions' – that which is unnatural – and Pevsner dismissing Modernistic designs as 'the bastard deformities of the Modern Movement.'[34] In this context, beyond its immediate descriptiveness, the epithet 'Jazz Moderne' used to label and condemn an inauthentic form of Modernism takes on a more sinister quality. Given that Mumford believed – in the early 1930s at least – that automation would eradicate work and replace it with the 'universal achievement of leisure', which he believed not only admirable but 'the largest justification for the mechanical developments of the last thousand years,'[35] it is miraculous that his perceptions of contemporary mass leisure did not make him more fearful of the future.

Modernism was authentic; all else was inauthentic. All forms of escape were undesirable, because they distracted from the reality of the present. They were mere 'Compensations and Reversions'[36] to borrow one of Mumford's chapter titles, signs that the looked-for harmony had yet to be achieved. The sheer volume and persistence of mass-produced goods which were the bearers of fictions other than that of 'pure' Modernism point to the error of Mumford's or Pevsner's diagnosis. For while there were numerous occasions when a happy convergence occurred between manufacturing technology, economics and the aesthetic and imaginative aspirations of Modernism, provided the consumer would bear the costs, the techniques of mass production could have stamped Pevsner's cardboard travelling case with circles, squares, rectangles, triangles, an alligator pattern, the Taj Mahal or the old bazaar in Cairo. It was dishonest to pretend otherwise or that a plain cardboard case was objectively superior or more 'natural' or more honest.

Charitably interpreted, through their actions, designs and polemics, the Moderns sought to share some of the excitement they felt at their own vision, as well as the material, aesthetic, moral, social and political comforts which they genuinely believed Modernism could deliver. However, in their zeal to achieve a strictly authentic Modern world for the masses, they could not allow that simpler, more immediate pleasures might coexist with it. To have done so would have been to undermine Modernism's

declared destiny, its authenticity compared with the alternatives, and admit that Modernism, far from being natural, was as synthetic as those condemned alternatives.

In reality, Modernism was also a fiction and an escape. It was founded on two forms of nostalgia: nostalgia for an age without alienation – whose very existence and supposed levels of human happiness were, to say the least, open to speculation – and longing for a more perfect future. Paradoxically, Modernism devalued the present as inauthentic. Its significance was reduced to that of a body of evidence, scrutiny of which was entirely geared towards the recovery or achievement of an amalgam of the qualities such remote times could have had, or might yet have. Modernism was the greatest escape and therefore by its own standards, inauthentic. Yet, by the standards of commerce, of the 'masses' – the purchasers of mass-produced goods – Modernism may have been better or worse, satisfying or unsatisfying, good or evil, but it was as authentic as any of the vulgar avenues of escape which Modernism so roundly condemned.

In practice, design which embraces a Modern machine aesthetic has tended to be reserved for objects or environments where its implicit and explicit qualities have been judged sympathetic to the actual or symbolic functions. Thus, Albert Kahn's regular, orderly factory architecture for Ford in Detroit and Giacomo Matté-Trucco's Lingotto factory became Modernist icons. The fictive technological and social harmonies implicit in much Modern design proved durably attractive to large corporations. Completed between 1954 and 1958, Mies van der Rohe's Seagram building in New York proved the model for thousands of steel and glass office blocks. Mies's imagery 'conjured up associations of efficiency, cleanliness, organization, and standardization which fitted the bill for what one might call the heraldry of big-business America.'[37] The famous or notorious, standard, industrially-produced I-beams which ran from top to bottom of the block were part of this, for not only were they expressive of the building's inner steel structure, they were a celebration of the near-infinite, but 'well-ordered' plenty which mass production – in its abstract, idealised form – was thought to supply. Stability, harmony and plenty were public promises at odds, to varying degrees, with the day-to-day realities of commercial life. Of Mies's imitators, William Curtis notes glumly, 'None of the excellence and most of the faults of the prototype were reproduced: the brash results are to be seen today in most major cities.'[38] Not only manufacturers, but service sector giants, educational

institutions, regional, national and international political or governmental organisations became deeply attached to this, ostensibly elevated, rational, industrial aesthetic.

Inside offices, something comparable was taking place.[39] From the early years of the twentieth century, offices were increasingly perceived of as analogous to factories. Accordingly, the office moved from furniture which allowed limited individuality, privacy and individual responsibility – such as high-sided, roll-top desks – towards flat steel desks, which provided none. The 'worker' could thus be more directly supervised. Like the assembly line, the dehumanising effects of serried ranks of steel desks has provided scope for polemic or satire, as in King Vidor's 1927 film *The Crowd* or Billy Wilder's *The Apartment* of 1960. Alternatives to this aesthetic of apparent rationality and efficiency – most notably, the *Bürolandschaft* or 'office landscape' movement which emerged in Germany in the late 1950s – have tended to emerge in times of relatively high employment. Employers, anxious to achieve efficiency and stability through the continuing allegiance of their workforce began using design to reinforce a sense of personal and group identity without, of course, sacrificing corporate values. The factory analogy was put in abeyance.

In domestic architecture, the machine aesthetic with its ideological component of mass production flourished in two provinces: exquisite confections for the exceedingly wealthy, and public housing. The Austrian émigré Richard Neutra built several houses for rich American patrons which exploited the structural possibilities of standard components, including the Lowell Health House, Los Angeles, of 1927, and the Kaufmann Desert House at Palm Springs of 1946–47. Mies van der Rohe's Farnsworth House of 1946 and Philip Johnson's Glass House similarly protest their contemporary, industrial credentials. But in each case, with the possible exception of Johnson's design, the mass-produced inflexion is subsumed under other, grander preoccupations. The whirr of the machine is barely to be heard.

In public housing, an attempt was made to close the gap between ideal and technological reality, and in doing so, to realise much of what had been rehearsed by some modernist practice – in Germany, Austria and Scandinavia, especially – and much modernist rhetoric before the Second World War. Through the mass production of building components the power of industry was to be put at the service of the masses – or electorate, as they might more properly be termed in this context. This was an attractive political prospect at a time when, after the irrationality of

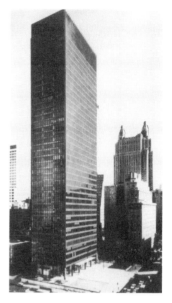

The Seagram Building designed by Mies van der Rohe, 1954–58. Identical, industrially produced components are organised into an image of ordered plenty, with modern technology as a source of harmony and power – a narrative with which corporate industry the world over wanted to be associated.

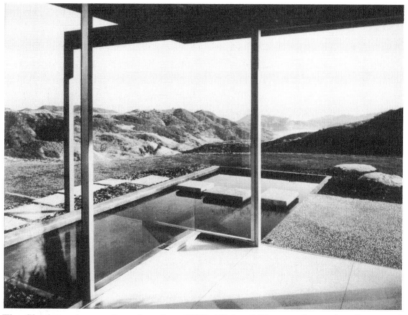

The Singleton house, Los Angeles, 1959, Richard Neutra. A poetic, abstracted machine aesthetic for the very wealthy. Industrial realities are, wisely, relegated, while the whirr of mass production as a democratic source of social and aesthetic harmony is barely to be heard.

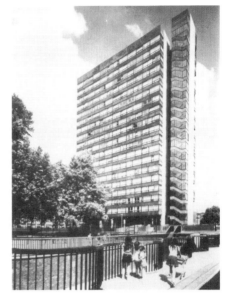

The Banner Estate, Islington, 1965. The 'rationality' and 'order' of industrial production expressed in much public housing was at one with post-war political rhetoric, and advertised the modernity of the sponsoring bodies – the GLC in this case. Mass production, replication, uniformity, used to house the mass of the population, clearly seen as equally uniform.

war, the 'making-over' of the world according to rational criteria had widespread appeal.

In Britain, the National Government had been promising such a comprehensive programme throughout much of the war; indeed, it was cited as a crucial reason for enduring danger and hardship during the war's prosecution. Afterwards, an immense building programme was undertaken, including the creation on greenfield sites of whole towns, more or less from scratch. The rhetoric of pre-war Modernism became mainstream political territory; with it came the Modern aesthetic, at least, as an ideal aspired to. The anti-Modern, historicist aspects of the defeated Fascist regimes made it still more attractive. The legitimacy claimed for Modernism as the authentic aesthetic for the present had political value to governments anxious to build a moral victory out of a military one.

For a while, at least, millions of people seemed reasonably content to move from the material deprivations of damaged, decaying, cramped or 'unfit' homes into new, Modern flats or houses, many in the new towns. The machine aesthetic employed made nods and gestures towards the Arts and Crafts scheme of a garden city. As in the commercial sphere, the elements of standardisation in the environments thus created helped advertise the corporate identities of the sponsoring bodies; such uniformity was also an indication that the masses were perceived of in abstract and homogeneous terms. In theory, this was mass production for the masses;

in practice, especially in the building of new houses, much of the building industry remained craft-based. Uniformity was also a function of economy – the most homes for the least cost. Economy, corporate political identity and a vague belief in the aesthetic, moral and social benefits of standardisation acted powerfully to make this version of Modern design a reality. The choice was not determined by some logic inherent in the techniques employed.

As each new tenant painted the walls of their new home or put up wallpaper, hung curtains, arranged their furniture, distributed their ornaments and conducted their lives, the distance between this Modern vision, however imperfectly realised, and their own ideas of who they – the 'masses' of the rhetoric – were, was to reveal itself with startling rapidity.

Following the horrors of war, the high debate underwent a fundamental shift in emphasis. After all, the machine had demonstrated an awesome capacity to destroy rather than, by its nature, construct. Many designers deserted or modified the high machine purity of which much pre-war, Modern design had spoken. The relationship of the machine to nature and 'organicism' had tended – with a few exceptions – to be confined to the realm of theoretical foundations; now, it was to be overtly expressed. Thus, Le Corbusier's 'primitive' experiments, his decision deliberately to let the grain of the wooden shuttering around moulded concrete leave its 'natural' marks on the finished surface, his theoretical construction of the 'Modulor', a proportion system which took as its starting point the human figure – albeit idealised at a height of six feet and unmistakably male.

High design in America embraced the organicism of Charles Eames, Eero Saarinen and others; in Italy, the Modernism of *la dolce Vita* was a variation, where the machine aesthetic was often modified by craft traditions and materials. In part, this reflected a national attachment to both the values and the materials associated with them – for which there was a wider, world market – and, in part, the decentralised character of much Italian manufacture. For unlike the classic model of highly centralised, highly mechanised mass production, Italian practice, apart from industrial giants such as Fiat or Olivetti, embraced small, loosely organised workshops for different stages of production, thus creating opportunities for flexibility, versatility, low wages and the criminal evasion of taxes. The fresh, craft-inspired Modern design of the Scandinavian countries also found an established place in the world market for high design. Meanwhile, in Germany, leading figures of the *Hochschule für Gestaltung* at Ulm, near Stuttgart, veered from violent allegiance to the notion of

design as a rational, problem-solving activity, in which even the socio-logical and psychological dimensions might be susceptible to scientific analysis, to a view held with almost equal violence, that it was an in-tensely intuitive human activity.

What, then, of the masses and of ideas of mass production? How did manufacturers respond to these newly identified perceptions colouring the high debate, or, more immediately, to the shifting perceptions of their customers? At no stage was the oft-predicted and long-desired abandon-ment of everything but 'good Modern design' – a changing concept at the best of times – attempted. Some designs which enjoyed high debate ap-proval did become commonplace, but these were seldom to be found in the realms of goods destined for personal adornment or the domestic environment. Organic and 'craft' Modernism had their popular manifes-tations, alongside streamlining and 'atomic' Modernism.

Streamlining, especially in American car design, graduated from aero-plane to space-rocket forms in the post-war period. In the first two post-war decades, the different forms of vulgar modernism gained ground in terms of popularity. But throughout these years, provided you could pay for it, all manner of historicist, escapist design was being manufactured, purchased and enjoyed. From the 'ranch-style' houses of newly created suburban prairies, to the mock Tudor or Neo-Georgian prettinesses of Home Counties England, the 'Queen Anne' television cabinets of Dynatron. Nor was imaginative travel confined to time. The 'Spanish-style home' previously the preserve of Hollywood stars within striking distance of Spanish prototypes in Mexico, was now nearly as likely to be found on Long Island as Long Beach and would probably include Spanish-style furniture; while on a more modest scale, the tenants of the new homes in the New Towns might choose to hang up their tooled leather Chianti bottles or castanets next to a convex mirror framed in curlicues of imita-tion 'wrought iron' depicting the outline of a guitar. The high debaters continued to sigh and sneer.

Yet, with so much of the environment being rebuilt and signs that the masses were increasingly willing to embrace some forms of Modernism, as their purchasing patterns seemed to suggest, it might have seemed that the inevitability of the Modern agenda was, after all, justified. The Mod-ern world was, finally, within sight. But the explosion of a Modern popu-lar culture among the young in the 1960s blew that vision away once and for all. For when it came – especially in the fields of fashion and design

Modernism and the mass production of myth

– it was not the rationality, the authenticity or the 'reality' of Modernism which was celebrated, but its artifice, its unreality, its whimsy. Standards of living were higher than before and there was a spirit of optimism about the future and what it might hold; but the popularity of Modernism in the 1960s was a graphic illustration of how aspirations to Platonic universalities were rejected, in favour of acceptance and indeed celebration of the contingent nature of reality. The fantasies – including those of the future – were for immediate enjoyment, for the present, for reality. Like the recreational drugs then enjoying an ever wider currency, they could make life more pleasant.

In common with most of the Moderns, Henry Ford had believed fervently in the merits of rationality and simplicity. Like them, he had been convinced such qualities were symptomatic of the production technology he had helped devise. The Moderns tried, with some success, to fashion an aesthetic, much of which was to be an expression of such aspirations. In 1927, Ford had learnt from bitter commercial experience the limitations of his own beloved, universal design. The collapse in demand for the Model T forced him to acknowledge his customers' taste for variety, entertainment and change. Nearly half a century later, the high debate was similarly compelled to re-evaluate its stance, faced with its own dwindling credibility. At last, the debaters attempted to embrace the Modern world as it actually operated, rather than as they would have liked it to have been. From staring fixedly, if romantically, at the machinery of mass production as the fount of all aesthetic, social and moral wisdom, their gaze began to encompass consumption. The agenda was, necessarily, revised. Under the critical umbrella of Post-Modernism, the masses – that abstract, ill-defined body of humanity in whose name the Modernist experiment had been undertaken – were swiftly killed off, only to be immediately resurrected in a newer, more exalted, more commercial personification: the consumer.

Notes

1 David A. Hounshell, *From the American System to Mass Production, 1800–1932* (Baltimore and London, 1984), p. 1; see especially nn. 3 and 4.
2 Siegfried Giedion, *Mechanization Takes Command, a contribution to anonymous history* (New York and London, n.d.), pp. 37–8, 134.
3 See John Heskett, *Design in Germany 1870–1918* (London, 1986), pp. 119–50.
4 Giedion, *Mechanization Takes Command*, pp. 491–2.
5 Serge Chermayeff, *Design and the Public Good, selected writings, 1930–1980*, ed. Richard Plunz (Cambridge, Mass., 1982), pp. 19–24.

6 Paul Greenhalgh, in *Modernism in Design* (London, 1990), pp. 8 and 10.

7 Henry Art Gallery, University of Washington, Seattle, Wash., *Art into life: Russian Constructivism 1914–1932* (New York, 1990), pp. 185–6.

8 Wilhelm Wagenfeld, 'Das Staatliche Bauhaus – die Jahre in Weimar', *Form*, 37 (Mar. 1967), 17–19, quoted by Gillian Naylor, *The Bauhaus Reassessed* (London, 1985), p. 112.

9 I am grateful to Dominic Stone for pointing this out to me.

10 Marianne Brandt quoted in *Bauhaus 1919–1928*, ed. Herbert Bayer, Walter Gropius and Ise Gropius (New York, 1938), quoted by Naylor, *The Bauhaus Reassessed*, p. 147.

11 Laszlo Moholy-Nagy, *The New Vision and Abstract of an Artist* (New York, 1947), p. 31; *Vision in Motion* (Chicago, 1947), p. 55, quoted by Naylor, *The Bauhaus Reassessed*, p. 145.

12 Kenneth Frampton, *Modern architecture, a critical history* (London, 1992), pp. 190–1.

13 For a detailed discussion, see Jeffrey Meikle, *Twentieth Century Limited, Industrial Design in America, 1925–1939* (Philadelphia, 1979).

14 Earnest Elmo Calkins quoted by Meikle, *Twentieth Century Limited*, p. 71.

15 Meikle, *Twentieth Century Limited*, p. 29.

16 Eanest Elmo Calkins quoted by Meikle, *Twentieth Century Limited*, p. 71.

17 Lewis Mumford, *Technics and Civilization* (London, 1946), p. 352.

18 Mumford, *Technics and Civilization*, p. 355.

19 Walter Benjamin, *The Work of Art in the Age of Mechanical Reproduction* (1936); quoted in Stephen Bayley (ed.), *Commerce and Culture* (London, 1989), pp. 35–7.

20 Aldous Huxley, *Brave New World* (first publ. London, 1932; repr. London, 1969), p. 18.

21 See Greenhalgh, *Modernism in Design*, pp. 13–14, in this connection.

22 Mumford, *Technics and Civilization*, p. 353.

23 E. Maxwell Fry, 'The Background of Work', *Design In Industry* (London, Spring 1932), pp. 10–12.

24 Nikolaus Pevsner, *An Inquiry into Industrial Art in England* (Cambridge, 1937), p. 38.

25 Raymond Williams, *Culture and Society* (London, 1990), pp. 295–338.

26 Pevsner, *An Inquiry into Industrial Art*, p. 11.

27 Pevsner, *An Inquiry into Industrial Art*, p. 12.

28 Pevsner, *An Inquiry into Industrial Art*, p. 11.

29 Mumford, *Technics and Civilization*, p. 316.

30 Mumford, *Technics and Civilization*, pp. 341–2.

31 Mumford, *Technics and Civilization*, pp. 303–307; the section is headed 'Sport and the "Bitch-godess"'.

32 Mumford, *Technics and Civilization*, pp. 315–6.

33 Mumford, *Technics and Civilization*, p. 299.

34 Pevsner, *An Inquiry into Industrial Art*, p. 38.

35 Mumford, *Technics and Civilization*, pp. 279–80.

36 This was the title of ch. 6, Mumford, *Technics and Civilization*, pp. 268–320.

37 William J. R. Curtis, *Modern Architecture since 1900* (Oxford, 1987), p. 266.

38 Curtis, *Modern Architecture*, p. 266.

39 See Adrian Forty, *Objects of Desire, Design and Society 1750–1980* (London, 1986), pp. 120–55; also, Lance Knobel, *Office Furniture* (London, 1987).

5 Mass production, design and us

How much is left of mass production in the late twentieth century? Clearly, as 'the combination of single-purpose machines and unskilled labour to produce standard goods',[1] it has not proved the universal solution to industrial efficiency it was once thought to be, let alone a panacea for social, economic, political or aesthetic problems. Yet, many of the ingredients developed by Ford in his extreme form of mass production survive. The single most newsworthy technical innovation, the moving assembly line, not only remains standard amongst the majority of automobile manufacturers, it figures in the manufacture of many other industrial products, from complex technical goods, such as audio equipment, to highly prepared foods. Among car manufacturers, the many industrial marriages that have occurred in the last twenty years would tend to suggest that ever greater levels of concentration are required if highly mechanised, capital-intensive manufacturers are to survive. According to the traditional view of mass production, it might be thought that this would inevitably lead to greater standardisation of the product.

As Charles Sabel and Jonathan Zeitlin have pointed out, however, the persistence and development of manufacturing strategies other than mass production oblige us to review its place in history, as well as how it functions. Rather than habitually ascribing to it the status of an ideal of industrial efficiency, to which all other forms are in various respects inferior, subordinate or anachronistic remnants of some older, soon-to-be-outmoded way of thinking, it can be argued that mass production was but one of a range of manufacturing strategies, each of comparable technological viability. The decision to pursue mass production at the expense of these alternatives arose, not because of 'an immanent logic of technological change', but because of 'some implicit, collective choice, arrived at in the obscurity of uncountable small conflicts'. Accordingly, Sabel and Zeitlin argue, the choices facing manufacturers in the future will be determined by social struggles and not by qualities inherent in the

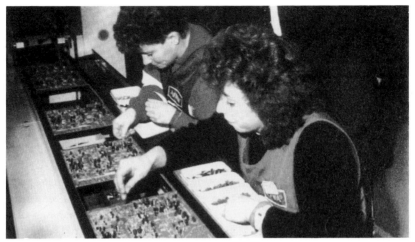

An assembly line in an electronics factory in Britain, 1989. The assembly line has proved one of manufacturing's most enduring tools, whereas the high wages which figured in Ford's theoretical account of mass production have been less persistent.

technologies themselves.[2] Which manufacturing strategies are adopted and exploited will affect the nature, type and design of the products made.

Perhaps one of the long-neglected aspects of the techniques of mass production will eventually be judged the most significant in terms of its consequences for design: the sophisticated handling of information. Ford liked to create the impression that part of the reason for the success of his company was that no one knew exactly what the cost of producing a Ford automobile was. Yet in Hounshell's opinion, the handling of information about costs and other production data by the Ford Motor Company was 'controlled and manipulated far more creatively than [by] any other company' considered in his book.[3] Practice at Ford was but one advanced manifestation of the sorts of control systems which had been developing as responses to the increasing speed at which materials were processed. The next step for manufacturers was to extend such systems beyond the factory gates.

'The first and controlling principle in the establishment of General Motors production schedules is that they shall be based absolutely on the ability of its distributors and dealers to sell cars to the public.'[4] Alfred Sloan's policies regarding product range and model renewal have been noted, as has General Motors' desire for a manufacturing structure which

favoured flexibility. The ability to be flexible can only be fully exploited if there is a constant flow of accurate, interpretable information from the market-place. Like Sloan's other innovations, statistical controls on production emerged following the crisis in car sales in the early twenties. To avoid producing too many or too few cars relative to demand, reports from dealers every ten days indicated 'the actual number of cars delivered to consumers, the number of new orders taken, the total orders on hand, and the number of new and used cars on hand'.[5] Rather than setting artificial product goals and straining to adhere to them, output levels were subject to constant modification.

James Beniger[6] locates these information-handling phenomena within the context of the emergence of an information society. The Industrial Revolution meant that capital rather than land became the principal source of wealth and power. In the information society, 'the bulk of [the] labor force engages in informational activities and the wealth thus generated comes increasingly from informational goods and services'[7], that is, a society where wealth and power spring, not from the mere possession of or ability to process raw materials, but from the ability skilfully to manipulate information.

Today, the importance of information handling is graphically illustrated by the car industry in Japan. Unlike those of Europe and the USA, it never passed through a phase where it catered exclusively for the needs of the rich with luxury products. Even as Japan became prosperous, imported cars such as Mercedes, BMW, Porsche, Jaguar and Rolls Royce held the highest prestige for Japanese businessmen. Similarly, Americans may turn to the Lincoln and the Cadillac, with expensive European cars as an alternative. The Japanese car industry has grown so effective that around the world it faces voluntary or legal controls on the number of cars it may export. One strategy to evade these restrictions is to build factories abroad. But because the restrictions tend to consider the number rather than the value of the cars exported, it has made sense for manufacturers to turn to the last areas of carmaking so far left largely untouched: the luxury prestige car and the sports car.[8] The forms these have taken are made possible by innovations in production, but the designs themselves are increasingly informed by elaborate, expensive programmes of market research. These do not just embrace statistical and economic 'facts', but also attempt systematically to grapple with the psychological and emotional dimensions of design.

If Japan is now the world's largest maker of cars, the USA remains the

world's largest market. In an effort to understand the sensibilities of some of their potential customers, Nissan Design International (NDI) was set up by Nissan and other Japanese firms in Southern California. NDI interprets Los Angeles for Tokyo. Market research showed, for example, that to the wealthy nostrils of America a particular type of leather smell was pleasing, whereas to those in Japan any smell seemed distasteful. Accordingly, the interiors of Japanese luxury cars tend to be finished without leather smell for the home market, while the smell is added for American exports.

Toyota sent a design team for three months to the fashionable resort of Newport Beach, California. Here they were obliged to live in a luxurious house, eat at expensive restaurants, to sail in the marina and drive fast, expensive cars. The team eventually designed the Lexus. Strict quality control, central to technical excellence, was extended to include the emotional characteristics of the car, down to the last details. For example, the size of the stitching on the leather covering to the steering wheel has been specifically designed to give the impression that it has been sewn on by hand, while a rubber bung at the bottom of the door ensures exactly the 'clunk' that research has shown signals quality. Within a year of its introduction, the Lexus was outselling both Mercedes and BMW in the United States.

The Mazda MX5, known as the Miata in the USA, was designed at Mazda Design, North America, by a team led by Tom Matano. The intention was to create a car reminiscent of the MGs, Triumphs and Austin Healeys of the 1950s and 1960s, popular imports into America in their day. The appeal of sports cars, given their expense and practical limitations, was deemed overtly emotional rather than rational. Accordingly, the front of the car has been given a 'smiling face'; while research from the psychoacoustic laboratory means that the exhaust note has been tuned to exactly that pitch which is thought most suggestive of a lively, exciting car. Once acquired, these skills of emotional manipulation are not confined to the top end of the market. According to Takayasu Matsui, the manager for design at Nissan, the look of the Micra was intended to foster an impression (or illusion?) of eco-friendliness with its rounded, 'organic' forms, reminiscent of Michelin man, and yet another smiling face.

At Nissan, designs begin with traditional sketches, which are then fed into a computer where they are converted into data and can easily be altered and manipulated. The full-size clay mock-up has been a staple among car designers since its introduction by Harley Earl in the twenties.

Modernism and the mass production of myth

Traditionally it takes about forty hours to make one, but linking the computer to an automatic clay milling machine has reduced this time to about eight hours. Total design time for new models has been cut by 40 per cent. This reduction is vital given the fluctuations of the market-place. A reduced 'lead-in' time means that manufacturers stand a better chance of creating models which will take advantage of trends as, when and while they occur. In conjunction with computer-aided manufacture, it becomes possible to exploit ever smaller niche markets, each with particular design requirements.

The Be – 1, the Figaro and the PAO, made in limited numbers by Nissan and sold only in Japan, are a demonstration of this phenomenon. The Be – 1 arose from an encounter between the Japanese designer Naoki Sakai and Nissan executives at a fashion launch in the early eighties. Produced in 1985, it was an early exercise in 'retro-styling', common enough in fashion, but at that time virtually unknown in the designs of the large carmakers. To achieve the desired effects, many of the visible or tactile elements were made using the manufacturing techniques of the fifties and sixties. This was felt to add to the authenticity of this new 'old' car; it certainly added to the price. The Be – 1 was followed by the still more successful Figaro and later by the PAO. Using the same chassis and running gear, each model was highly designed to give it entirely distinctive characteristics. Computers were being used to create the illusion of the sort of individuality which small European makers have practised in the past. Eriko Uehara of the Interior Design studio at Nissan explains that opening the roof on the Figaro was meant to feel like 'opening a jewel box'.[9] Inside, the driver can control this sophisticated, late twentieth-century motor car using clusters of highly ornamental *faux naïf* fifties' plastic knobs set amid heavily styled alloy details. The Figaro was promoted with a feature film as well as many accessories – for the owner rather than the car. The comparison which Alfred Sloan drew between car styling and the fashion industry is still more apt today than when he first made it in the 1920s.

Opened in 1991, Amlux cost Toyota £80,000,000. Housed in a single building it is a gigantic exhibition and auto theme park. Of the five million visitors who came to the centre in its first two years, many took the opportunity to design their own cars on a computer and take home a colour print of their design, or thrilled to the sight of a gangland car chase in the Amlux cinema, complete with bodysonic seats. Plans are afoot to exploit virtual reality technology. Amlux is more than a public relations

exercise: it is an elaborate tool of market research. It attempts to tap into the emotional psyches of millions of Japanese, and to make use of that information in the designs of Toyotas yet to come.

The most recently completed large-scale carmaking plant suggests that it is the innovations of Sloan, rather than Ford, which continue to be developed and refined. Throughout, the rapid, accurate processing of information is critical to success. The new Fiat plant at Melfi in the south of Italy has been described, for publicity purposes, as the world's first 'integrated factory'. At one end of the three million square metre compound are plants belonging to twenty-one component suppliers; at the other stands the assembly line for the Punto, successor to the Uno. At its core is one and a half kilometres of private motorway, which links the whole together. Economies of scale – by which Ford set so much store – are still valued. Where Fiat relied on up to half a dozen short-term contract suppliers for glass for the Uno, they have just one long-term contractor for the Punto. But the emphasis remains very much on flexibility. 'Sequenced production [is] the ultimate form of just-in-time,' according to Daniele Bandieva, head of the plant. 'The moment we begin production of a certain car, we notify the suppliers by computer who then begin their own production, so that, for example seat number 50 arrives just when car number 50 reaches the seat assembly point on the production line.'[10] Critically, space is allocated directly next to the beginning of each production line for retooling, thus enabling the Melfi plant to switch model without shutting down. Alberto Pianta, Fiat's head of production engineering, emphasises the commercial importance of flexibility: 'We are dealing with the ephemeral, where the key is the speed of meeting the whims of the market. At Melfi we can respond to shifts in taste within the product range in just two weeks. We shall be manufacturing only what the client has actually ordered. That is the future.'[11]

Yet, reviewing the appearance of the New Ford Mondeo, one journalist noted, 'the Mondeo smacks of a . . . return to the one-size-fits-all approach pioneered by the company's founder. "You can have any colour Model T so long as it's black" has now been replaced with "You can have any model as long as it's a Mondeo".'[12]

At regular intervals and in different countries, designs emerge which seem directly to contradict the tendency towards constant change and to vindicate Ford's, rather than Sloan's, approach to design. The idea of a democratic, universal, basic car has haunted and inspired car manufacturers ever since the Model T first made its mark, giving rise to the Austin

Modernism and the mass production of myth

Seven, Fiat's Topolino before the Second World War and the 500 after, the Volkswagen 'Beetle' in both its Nazi and 'liberal American' phases, the Citroën 2CV, the Morris Minor and the Mini (still in production in 1994). Where state and manufacturer have had close links – as in Fascist Italy or Germany – the political dividend of social cohesion has been a consideration. Economic stringencies in Europe after the Second World War stimulated a flurry of such 'universal' cars. Like the Model T, the ascribing of values and characteristics to a motor car may occur long after its design has been conceived of. The Volkswagen Beetle was successful in America for, among other reasons, its apparently unchanging, 'rational' design, at a time when most Americans seemed transfixed by the unfolding melodramas of the latest Plymouth, Dodge or Cadillac. That its appeal was partly irrational was demonstrated when the designers started to modify the bodywork, making it still more generous, giving it a curved windscreen instead of a flat one and generally 'restyling' it to resemble its cartoon-like *alter ego*. In most recent cases, 'iconic' mass-produced cars, whose designs seem stable over time and advertise the 'reality' of their machine origins, have had a particular emotional appeal which expresses their drivers' 'rational' or non-conformist aspirations. They are dependent for their appeal on the perception that the designs of other cars are constantly changing. Today, they are a part, rather than the antithesis, of that phenomenon. The Mondeo is unlikely to follow this pattern, for while it seems set to be manufactured in very large quantities, it falls into the category of what has inelegantly been termed 'Glocal' cars – 'a standard overall design with the flexibility to build in local variations to meet individual markets.'[13]

As recent developments at Ford have indicated, the computer has opened up the prospect of matching output with demand exactly and simultaneously. At the car showroom, the customer is able to choose from a wide range of models, body types, colours, technical and trim specifications. Using a direct computer link to the factory, the customer's car will only then be 'commissioned' and manufactured. In this way manufacturers avoid losses of return on capital resulting from acres of new cars waiting to be sold, while customers may eventually expect from the large producers levels of 'customisation' comparable with those which were once the preserve of the small-scale, luxury market.[14] From the design perspective, this process fosters possibilities for diversity.

At the beginning of this century in Germany, Peter Behrens and AEG's production engineer Michael Dolivo-Dobrowolsky worked together to

produce a range of electric kettles. Using a strictly limited number of standardised, interchangeable components and a variety of textural and decorative finishes they had the potential to supply their customers with eighty-one different models of kettle, although only thirty were actually put before the public.[15] Today (1994) near the end of the century, the possibilities of exploiting variations in the designs of industrially produced products is steadily increasing, largely because of increased use of computers. Might CADCAM eventually be wrenched from the hands of the designers, and, in the manner of Toyota's Amlux interactive computer terminals, linked directly to the customer, enabling them – within limits – to 'design' their own cars? Alternatively, might developments in the politics of the environment drive governments to urge manufacturers to re-examine Ford's vision of ultra-efficient mass production, in order to maximise the use of limited material and energy resources? Those who have lived in a century which has witnessed the realisation of so many 'impossibilities' should hesitate before setting limits on the possibilities of the next. 'Perhaps the greatest danger in a machine-dominated America', suggested Daniel Boorstin – and he might have added a machine-dominated Europe or Japan, 'is the temptation to believe that our world is more predictable than it really is.'[16]

What, then, is left of the Modern Movement's ambitions for mass production? Aesthetics, technics and society have not miraculously been turned into one seamless, harmonious whole, as the Moderns might have wished. Nor, allowing for the misguided altruism which lay behind such a vision, are there many today who would wish to see it; nor does it seem likely. On the other hand, mass production has demonstrably been a provider on a large scale of countless devices, comforts and pleasures to millions who might not previously have enjoyed them or their equivalents. But the nature of the mechanism, the purposes to which it has been put and the increases in material comfort made possible by its agency have only occurred in the ways they have because of the evolving characteristics of a political, economic and social fabric of which it is a part. Mass production is no more autonomous than any other technology.

This helps to explain how the tendency for mass production to refine form – which captured the Modern imagination – has been and always was sporadic, only to be found in some spheres and not in others. Those examples which supported the idea were celebrated, while those which did not were ridiculed or ignored. Yet both happened. The inevitability of

the refining process can now be seen as illusory. As John Heskett[17] has pointed out, in addition to the simple bentwood chairs which Le Corbusier believed possessed 'nobility',[18] Thonet offered a whole range of highly decorative models, for which – outside of the café trade, perhaps – there was a market. Indeed, even the identification of bentwood furniture as a mass-produced product is open to question. Much assembly of parts and the weaving of cane seats was labour-intensive rather than highly mechanised. Plainly, some measure of unnatural selection was being exercised to vindicate the notion of an evolutionary industrial machine aesthetic.

In retrospect, it seems that the lessons of the Grand Rapids furniture makers, the American clockmakers, Behrens' electric kettles and the American carmakers – with their emphasis on the manipulation of standardised parts to create apparent variety, rather than standardised products – pointed more accurately to the potential of mass production and some of its aesthetic consequences. Critically, in each case, the character of the market-place – the masses of abstract theory – was taken into account. Pevsner complained that, 'to plead for better design in manufactured wares will remain a futile task, unless the commercial aspects of the problem, unpleasant as they may sometimes be, are carefully taken into account.'[19] Few Modern minds persistently acknowledged as much, though most would have shared his unease at the prospect of commerce. As Greenhalgh puts it: 'The Modern Movement was concerned almost wholly with means of production rather than consumption; the perfection of production would lead to a higher form of society.'[20]

This blindness can be accounted for in a variety of ways. Among them, it must be acknowledged that the notion of engineering and engineers as representing something more heroic than simply a branch of commerce had been evolving for at least a century. The engineer was increasingly seen as belonging to a profession, rather than a trade. The idea of heroic shopkeepers was regularly put forward, but difficult to sustain. For liberals, abstract ideas about technology presented a path by which capitalism – savaged, justly many thought, by Marx – might be rehabilitated. The engineer was seen as closer to the supposed altruism of the scientist and, to a lesser extent, of the inventor, than to the blatant self-interest of the retailer. In the United States and Western Europe, the importance of commerce to national prosperity and security was regularly invoked at a political level, but seldom at a popular one. In popular British literature, the first two-thirds of the century saw no end of illustrated books with titles like *Conquests of Engineering, The Boy's Book of Wonder and*

Invention, or even *The Wonder Book of Engineering Wonders.*[21] One would be hard-pressed to find titles comparable in tenor, number or wonderment which dealt with retailing.

Another reason why the Moderns ignored consumption may have been that engineering was a legitimate, male activity, whereas retailing catered for the aspirations of shoppers; and shopping – in theory, at least – was largely women's work, unpaid and unserious, frivolous by definition, except to the extent that it enabled the comforts of home to be sustained. In trying to explain the aggravating persistence of 'pseudo-cubistic shapes' in relatively expensive celluloid articles, Pevsner quoted one 'modern-minded designer' who attributed it to ' "that wretched women's' dressing-table mentality" '.[22]

At a more fundamental level, there remained an underlying belief that engineering, like art, was a creative, imaginative activity, whereas distribution, retailing, buying, using or consuming were not. Yet, the truth which the Modern Movement steadfastly refused to contemplate was this: the logical consequence of mass production is mass consumption. And the masses – the actual people who worked *and* shopped, rather than the creatures of the Modern imagination – had views too, a whole range of them.

It is worth identifying the masses of the imagination – the majority and the mob – a little more closely; for to do so reveals concerns which underpinned the high Modern debate. Not only were the masses that noble, oppressed, amorphous, homogenous body of labouring humanity, they were also – at times – the people who might surrender themselves to sensuality if they danced to jazz, might be seduced by the spectacle of the cinema, might become violent after watching a game of baseball, might imagine that objects had meanings and pleasures with a value greater or other than that habitually ascribed to them by Modern orthodoxies. The masses were one of the abstract concepts of Marxism, out of which the Modern Movement fashioned its own schizophrenic construction. They were invariably other, usually poorer people, and at the same time they were a blank screen onto which the Moderns projected themselves. And it was themselves they were afraid of.

Today, in the Western imagination, 'masses' are only to be found in distant countries such as China, India, Vietnam, Korea or Pakistan. They are ascribed many of the masses' traditional qualities: they are different, homogenous, anonymous, and their indigenous cultures are perceived as threatening, as controversies over immigration regulations vividly

demonstrate. In addition, they provide an apparently endless supply of cheap labour, which occidental, no less than local entrepreneurs are eager to exploit. If, as seems likely, they become consumers as well as producers, then Western manufacturers may be obliged, in their own self-interests, to differentiate – a courtesy they already accord the Japanese for precisely this reason.

In design, Post-Modernism was a product of mass production. It provided a critical umbrella under which high debaters – building on the explorations of critics like Reyner Banham and Robert Venturi – could formally consider the meaning and consequences of the snow storm of design possibilities which the technology of mass production has precipitated; it also provided an opportunity to reassess many of the orthodoxies of Modernism. These included those key theoretical areas where aesthetics and value had been ascribed with reference to an abstract, idealised idea of mass production and its 'inherent' characteristics. In the process, attention switched from mass production to consumption – not *mass* consumption, for the implicit homogeneity of such a term has proved fictitious.

This debate was at its most intense at a time in Western Europe, the United States and, to a lesser extent, Japan when the politics of collective responsibility and consensus were being supplanted by an ethos of fierce individualism. 'Society does not exist,' opined one of the new perspective's most ardent and pernicious champions. The new climate, the appearance of solid economic growth and rising standards of living for many led, inevitably, to a great deal of shopping. With political and moral arguments about the fundamentals on which society is to be based apparently exhausted, and with manufacturing industry a bloody battlefield, strewn with the corpses of traditional left-wing causes, liberal attention shifted to two newly identified and potentially cross-party phenomena at either side of mass production: firstly, 'the environment' – all that which, potentially, industry might use up or lay waste in its search for raw materials and energy; and secondly, 'consumerism', the dirty word for shopping. These two preoccupations are intimately linked. They provided, among other things, a new moral foundation for the criticism of shopping and of the quality, 'values' and morality of the goods bought. In certain key respects, we have been here before.

At its most astringent, environmentalism directly addresses moral, social, political and economic dilemmas about our utilisation of resources

and choice of priorities. It also proposes respect for the natural world, rather than the 'conquest' and 'mastery' of earlier decades. It is directly concerned with monitoring and modifying the means of production – principally mass production – as well as with the consequences of consumption. In some Utopian forms, however, it entertains de-industrialised fantasies of a world without mass production, or, indeed, the machine in any of its sophisticated guises; and aims at the elimination or drastic reduction of consumption in order to achieve some remodelled, morally superior, spartan existence, where only what is 'needed' is produced. The moral consensus which would require such a change of direction has yet to emerge.

In these concerns can be discerned echoes of the Modern incomprehension of how industry does or could work, as well as a new avenue for anxiety about material plenty. Those who choose may stamp firmly on those pleasures of which they do not approve. Consumerism is the more democratic form of the sins of luxuriousness and materialism, previously confined to the wealthy. Until the nineteenth century, the poor had to make do with drunkenness, sensuality and vulgarity. When the material goods supplied by mass production became available, bad taste could be added to the moral indictment.

Part of the responsibility for the tendency to place a disproportionate value on material possessions must be laid firmly at the feet of those high moralists of the Arts and Crafts and Modern Movements. 'Have nothing in your home which you do not know to be useful or believe to be beautiful,' exhorted Morris – as if it mattered that much! It was the Arts and Crafts Movement which gave the relationship between people and things that extra twist, whereby responsible people were invited to believe that, more than ever before, the nature of the aesthetics which informed design had a significant and direct moral effect on society and on the individual. It is a small step to move from believing that things may not only express, but define individual morality, to allowing that they may potentially do the same for all other important areas of life. The symbols risk supplanting the deeds.

The Aesthetic Movement, predominantly middle-class, carried this fastidiousness further. Arguably, it may be seen as the first conscious design reform movement of the industrial age in which shopping played a central role. From a contemporary perspective, it is instructive to remember that it embraced both the studied uselessness of the idle, for whom the preoccupation with pleasures derived from things excluded

most other activities, as well as those who were socially and politically active.[23] Shopping and social responsibility need not necessarily be mutually exclusive. Indeed, the Aesthetic Movement witnessed the first widespread manifestation of shopping as dissent. Then, as now, in our own age of the 'ethical consumer', the danger is to mistake the making of choices about material goods as anything other than a symbolic or at best a marginal political act. Shopping is a minor branch of politics, not a substitute for it.

The astringencies of the Modern Movement may be seen partly as an attempt to reconcile a desire for material plenty – the promise of mass production – with moral comfort. Goods produced by industry might be the result of the exploitation of labour, and to buy them could fuel the evil engines of capitalism. By shopping only according to an elaborate moral artifice, the activity is elevated on to a higher plane. One may thus enjoy material comfort, without being unduly troubled by doubts about self-indulgence: luxury without luxuriousness, freedom without responsibility. When, by the 1980s, some of the theoretical foundations of Modernism had crumbled, this measure of moral and aesthetic worth was referred to only quietly. The decade which witnessed – in Britain at least – an effulgence of historicism from Colefax and Fowler to the DIY superstores, also saw limited outbreaks of the camp austerities of 'high tech'.

Design is fiction. Mass production increases the quantities in which these fictions can be supplied, and there are indications that it has great potential for increasing their variety. What, then, of their quality and type? Are those with which we are supplied chosen by capitalism to further its own purposes of stimulating consumption? Undoubtedly, this is so. But, capitalism – manufacturers, distributors, retailers and designers – only succeeds if they accurately judge the tastes of the market. The history of commerce is littered with economic casualties and fatalities resulting from miscalculations of the imagination. For capitalism to succeed, we conspire with it. If we are to enjoy the imaginative licence of mass-produced design, we are obliged to meet the responsibilities which come with it. As Reyner Banham put it nearly forty years ago:

> Both designer and critic, by their command of market statistics and their imaginative skill in using them to predict, introduce an element of control that feeds back information into industry. Both designer and critic must be in close touch with the dynamics of mass-communication. The critic, especially, must

High Modern machine aesthetics are occasionally still to be found, as shown by this filter coffee machine designed in-house by Braun in 1987. They figure largely in the realm of 'design classics', that booming trade in Modern nostalgia, in which we covet for ourselves the optimism of the recent past, whatever shortcomings the intervening years have laid bare.

Illustration from advertisement for replacement doors for kitchen units, 1994. 'My kitchen always looked what it was – old fashioned and mass-produced,' says the housewife of the copywriters' imagination. 'It was functional enough, but so boring and uninspiring – I hated it ... But now ... [thanks to machine-made, but old-looking door panels] I've got exactly what I wanted.'

have the ability to sell the public to the manufacturer, the courage to speak out in the face of academic hostility, the knowledge to decide where, when and to what extent the standards of the popular arts are preferable to those of the fine arts. He must project the future dreams and desires of people as one who speaks from within their ranks. It is only thus that he can participate in the extra-ordinary adventure of mass-production, which counters the old, aristocratic and defeatist 19th-century slogan, 'Few, but roses', and its implied corollary, 'Multitudes are weeds', with a new slogan that cuts across all academic categories: 'Many, because orchids.'[24]

To say that many forms of design are equally legitimate is not to assume that they are equally good. If diversity and choice is to be celebrated, then the nature of the fictions supplied or demanded requires close scrutiny: more debate, not less.

The responsibilities of those who enjoy the 'extra-ordinary adventure of mass-production' extend to those whose labour makes it possible. Today, working in factories where mass production is practised may be marginally less brutal than the regimes of Highland Park or the River Rouge in the first half of this century, but that is very much open to question. The small lettering which reads 'Made in Korea' or 'Made in China' on the undersides of famous European and American branded goods reminds us that even Ford's ambivalent adherence to high wages as an integral part of mass production seems, for the present, to have few imitators. While industrial design in the Modern tradition may occasionally reveal the techniques which lay behind a product's manufacture, as a rule it tells us nothing about the human or physical conditions in which manufacture occurs, and what it does tell us is usually a lie. Roland Barthes identified this phenomenon in 1955 with regard to the, then, new Citroën DS 19:

> It is obvious that the new Citroën has fallen from the sky inasmuchas it appears at first sight as a superlative *object* . . . it is the dove-tailing of its sections which interest the public most: one keenly fingers the edges of the windows, one feels along the wide rubber grooves which link the back window to its metal surround. There are in the *D.S.* the beginnings of a new phenomenology of assembling, as if one progressed from a world where elements are welded to a world where they are juxtaposed and hold together by sole virtue of their wondrous shape.[25]

Is the lie immoral? Should design proclaim the social as well as the technical 'reality' of a product's origins? Design is *always* fiction. Fiction is always lies, or rather illusions. Like the illusions of film, they may be used to illuminate or obscure, but must engage, may stimulate and inform,

id after massive public demand ■ Price to be about £8000 to £9000

Four-seat open top Concept 1 shares lower body and drive units with the hard top car. Gets same engine options too

The mass production of irony and illusion. The 'rational' Nazi peoples' car was rehabilitated for the Modern, liberal middle classes, acquired 'beach-cred' in California and then died, living only among devotees and in folk memory. In California, in the late twentieth century, it is reborn as Concept 1, a cartoon of its former self. VW will put it on the market in 1998.

and thereby entertain. The illusions chosen must fill cinemas and empty shops. They do not have to fill all cinemas or empty all shops. There is scope for variety. Equally, given that the business of design is firmly located in the apparatus of capitalism, there will be omissions. Yet, precisely which illusions are presented to the public arises partly in response to society's preoccupations. Like art, they will also form part of its discussions.

It is not only legitimate but essential to ask why the tedium of assembly line work persists; why long hours and low wages seem to have been supplanted by longer hours and lower wages. There is a politics to design and, as Banham suggested, the style and content of the fictions require scrutiny. In his book *Objects of Desire* (1986), Adrian Forty is particularly adept at uncovering the myths, injunctions and strictures which the tools of industrial design can reinforce. The degree to which a product masks the facts of its origins has been described as 'the classic commodity fetish'.[26] But, given its track-record as a commentary on the nature of work – particularly in the hands of the Arts and Crafts and Modern

Modernism and the mass production of myth

Movements – as a debating tool, design will usually remain oblique. It would be foolish to imagine that working conditions where the products of mass production are created could be significantly improved by changes in those products' designs.

Those who have access to the benefits of mass production have responsibilities to those who don't. Clearly, in a society which tolerates, for example, thousands of homeless people, whose access to material possessions may consist of little more than temporary residence in a cardboard box, something is terribly wrong. But homelessness provides occasion for working towards a more equitable distribution of wealth and power, rather than a case for denying the significant and constructive role which material possessions can play in creating a sense of personal and collective identity. Being censorious about consumption may inhibit consumption and deliver a *frisson* of abstinence to the materially comforted; it is unlikely to divert either political will or money towards ensuring a decent standard of housing for everyone. Material possessions have the potential both to blur (and sometimes eradicate) social distinctions and to reinforce them. Social mobility and social stability are not necessarily incompatible. If they are, then the poor will always be with us, for unlike the underprivileged they require no action of us.

Consumers need not be the unthinking, voracious animals of critical analysis. At the commonplace level, the choice facing the consumer of mass-produced goods is not, is this Ford Escort better or worse that its identical counterpart? We expect them to be identical (and complain if they are not). To that extent, standardisation, the hall-mark of mass production, can be a test of authenticity. We choose between different products. These products are not neutral but come bearing emotional charges, intended by designer and manufacturer to part us from our money. From then on, we set about creating the authentic, unique personal object. We may add personal ornaments; we may modify the engine to increase power – altering the sound it makes; or maintain it badly – altering the sound it makes; dents and scratches and repairs will each carry memories. The events in our lives with which this object is involved will alter our feelings towards it. Through our emotions, we have the potential to make each mass-produced object unique. Even if it remains unaltered, from the day of purchase we change it. We create a real, imagined individuality. As countless youth cultures since the Second World War have demonstrated – no less than the owners of motor cars – the meanings which

manufacturers and designers invest in their products are open to mediation and subversion.

There are many processes by which we arrive at a sense of self and a sense of our identity in relation to the rest of the world. We authenticate who we are according to the quality of our personal relationships – love and friendship, to give them their commonplace names. In this respect, as shown in chapter one, Ford's record was mixed. We also authenticate our identities according to the extent to which we engage in and help evolve social institutions and codes of conduct. Ford's willingness to engage was unmistakable, even if from a contemporary perspective we may question some of the aspirations of the man and his times. Lastly, it used to be the case that part of one's identity sprang from a sense of place, and with it, culture. The opportunities which the machine has presented have served to undermine this process and supplied at least two channels by which it may be made good. Firstly, if we choose, the machine makes possible access to information and education. Geographical mobility may be matched by intellectual and social mobility. In addition, just as in home photography, where the machine is used to authenticate personal histories and identities (and, incidentally, to interfere with location and the passage of time, thus compromising experienced, immediate 'reality') the machine, mass production, is used to supply objects for the material dimensions of our imaginations.

Greenfield Village is in many ways a classic, if grandiloquent, example of this phenomenon. The place where Ford was born and grew up proved fugitive; it was mutating in front of his eyes. Greenfield Village – his response to this fact – was made possible using the agency of the machine to transport buildings from their original locations to Michigan. The 'Village' aspects of Greenfield Village were created by Ford to celebrate the values of a culture over which the machine had yet to exercise its powers of dislocation to the full (although, in a sense, America is a creature of dislocation; everyone, including native Americans, came from somewhere else). The machine has been used to create a wholly imaginative, fictional sense of place. This place never has existed and does not exist, except as an emotional truth. It is an attempt to counter dislocation, by the creation of an artificial location, created by further dislocation. Ford was able to shop on a scale available to few others. But the ends of his shopping – to acquire imaginative material to authenticate his own life and his views of the world – are commonplaces of Modern life.

Modernism and the mass production of myth

To condemn the Cotswold cladding on a terraced industrial cottage or the 'Spanish-style' house on Long Island as fakes is to miss their point. They are not intended as statements of fact. They are not lies, but fictions, illusions, to be enjoyed and used at that level. In the Modern World, we *must* create, to define some aspects of who we think we are. Greenfield Village, on the other hand, exists in that limbo inelegantly described as 'faction'. It is too artificial to be accepted as pure fact, and insufficiently artificial to be enjoyed solely on the level of fiction. Both commodities are there, but are sometimes difficult to distinguish from one another. This is seldom the case in private environments where there are few if any didactic functions and many expressive ones.

Nonetheless, most of the buildings and objects at Greenfield Village exhibit characteristics of mass-produced commodities. As with many of the illusions borne by mass-produced objects, at Greenfield Village participation in the illusion provides for the transcendence, not only of place, but of time. Many of the buildings are typical, replicable, objects which may authentically represent all others of their type, because of their typicality. Standardisation is a measure of their authenticity. Thereafter, the same objects are imaginatively recreated to make them individual. The bicycle shop belonged to the Wright Brothers. It differs little from other bicycle shops in small-town America in the 1890s, but knowledge of its associations lent it a further level of meaning to Ford and to millions of visitors. The generic is made individual by the associations brought to it.

At Greenfield Village, as in contemporary urban life at the end of the twentieth century, fear of the consequences of dislocation, together with fear of the consequences of machine replication – mass production as an abstract idea – are countered with the use of the actual machinery of mass production to re-authenticate identity. Objects, products, goods purchased help us to define ourselves to ourselves and to others; the things with which we surround ourselves help to tell us and others who we think we are. In design, as in home photography, mechanical replication has the potential to assist in the creation of authentic realities, authentic accounts of the self. And it should be noted that authentic in this context means legitimate, but not superior and not complete.

Notes

1 Charles Sabel and Jonathan Zeitlin, 'Historical Alternatives to Mass Production; Politics, Markets and Technology in Nineteenth-Century Industrialisation', draft of article for *Past and Present* (London, 1985), p. 1.

2 Sabel and Zeitlin, 'Historical Alternatives', p. 2.

3 David A. Hounshell, *From the American System to Mass Production, 1800–1932* (Baltimore and London, 1984), p. 271.

4 Albert Bradley, economist at General Motors Statistical Department in an address to the American Management Association, quoted by James R. Beniger, *The Control Revolution, Technological and Economic Origins of the Information Society* (Cambridge, Mass., and London, 1986), p. 311.

5 Bradley, quoted in Beniger, *The Control Revolution*, p. 311.

6 Beniger, *The Control Revolution*, p. 311.

7 Beniger, *The Control Revolution*, p. 426.

8 Much of the following is drawn from *Equinox*, 'Zen on Wheels', Channel 4, 22 August 1993.

9 Interviewed in *Equinox*, 'Zen on Wheels'.

10 Quoted by John Eisenhammer in 'Fiat counts on revolution', *The Independent,* 28 Sept. 1993, p. 27.

11 Quoted in Eisenhammer, 'Fiat counts on revolution'.

12 Phil Dourado, 'Little Glocal difficulties', *The Independent on Sunday; The Sunday Review*, 5 Sept. 1993, p. 69.

13 Dourado, 'Little Glocal difficulties'.

14 Kevin Eason, 'Ford turns its back on founding father', *The Times*, 8 Oct. 1993; Kevin Done, 'Ford to streamline stock distribution', *The Finacial Times*, 9 Oct. 1993, p. 4.

15 John Heskett, *Design in Germany 1870–1918* (London, 1986), pp. 139–40.

16 Daniel J. Boorstin, *The Republic of Technology, Reflections on Our Future Community* (New York, Hagerstown, San Francisco, London, 1978), p. 94.

17 John Heskett, *Industrial Design* (London, 1980), p. 43.

18 Quoted by Lance Knobel, *Office Furniture* (London, 1987), p. 28.

19 Nikolaus Pevsner, *An Enquiry into Industrial Art in England* (Cambridge, 1937), p. 4.

20 Paul Greenhalgh (ed.), *Modernism in Design* (London, 1990), p. 14.

21 Cyril Hall, *Conquests of Engineering* (London, Glasgow and Bombay, n.d.); Charles Ray (ed.), *The Boy's Book of Wonder and Invention* (London, n.d.); *The Wonder Book of Engineering Wonders* (London and Melbourne, n.d.).

22 Pevsner, *An Enquiry*, p. 99.

23 Mark Girouard, *Sweetness and Light, The Queen Anne Movement 1860 to 1900* (Newhaven and London, 1984; first publ. 1977).

24 Reyner Banham, written in 1955, published in *Industrial Design* (Mar. 1960) and included as 'A throw-away aesthetic' in Penny Sparke (ed.), *Design by choice* (London, 1981), pp. 90–3.

25 Roland Barthes, *Mythologies* (London, 1986; first French edn. 1957), pp. 88–9.

26 John Staudenmaier SJ, in correspondence with the author, 5 Dec. 1993.

Bibliography

Edson Armi, C. (1988), *The Art of American Car Design, The Profession and Personalities*, Pennsylvania and London.

Babson, Steve, with Ron Alpern, Dave Elsila and John Revitte (1986), *Working Detroit, The Making of a Union Town*, Detroit.

Bardou, Jean-Pierre, Jean-Jaques Chanaron, Patrick Fridenson and James M. Laux (1982), *The Automobile Revolution, The Impact of an Industry*, trans. and ed. James M. Laux, North Carolina.

Barthes, Roland (1986), *Mythologies*, London.

Bayley, Stephen (ed.) (1989), *Commerce and Culture*, London.

Bayley, Stephen (1990), *Harley Earl*, London.

Beniger, James R. (1986), *The Control Revolution, Technological and Economic Origins of the Information Society*, Cambridge, Mass., and London.

Benson, Allan L. (1923), *The New Henry Ford*, New York.

Boorstin, Daniel J. (1987), *The Republic of Technology, Reflections on Our Future Community*, New York, Hagerstown, San Francisco, London.

Carrington, Noel (1935), *Design and a changing civilisation*, London.

Chandler, Alfred P. (ed.) (1964), *Giant Enterprise, Ford, General Motors, and the Automobile Industry, Sources and Readings*, New York.

Curtis, William J. R. (1987), *Modern Architecture since 1900*, Oxford.

Epstein, Ralph C. (1928; repr. 1972), *The Automobile Industry, its economic and commercial development*, Chicago, New York and London.

Ford, Henry, in collaboration with Samuel Crowther (1922), *My Life and Work*, London.

Forty, Adrian (1986), *Objects of Desire, Design and Society 1750–1980*, London.

Frampton, Kenneth (1992), *Modern architecture, a critical history*, London.

Garrett, Garet (1952), *The Wild Wheel, The World of Henry Ford*, London.

Giedion, Siegfried (n.d.) *Mechanization Takes Command, a contribution to anonymous history*, New York and London; originally Oxford, 1948.

Girouard, Mark (1984), *Sweetness and Light, The Queen Anne Movement 1860 to 1900*, Newhaven and London.

Greenhalgh, Paul (ed.) (1990), *Modernism in Design*, London.

Cyril Hall (n.d.), *Conquests of Engineering*, London, Glasgow, Bombay.

Heskett, John (1980), *Industrial Design*, London.

Heskett, John (1986), *Design in Germany 1870–1918*, London.

Hine, Thomas (1987), *Populuxe*, London.

Hounshell, David A. (1984), *From the American System to Mass Production, 1800–1932*, Baltimore and London.

Huxley, Aldous (1969), *Brave New World*, London.

Knobel, Lance (1987), *Office Furniture*, London.

Lacey, Robert (1986), *Ford, the men and the machine*, London.

Lewchuck, Wayne (1987), *American technology and the British vehicle industry*, Cambridge.

Lewis, David L. (1976), *The Public Image of Henry Ford, An American Folk Hero and His Company*, Detroit.

Meikle, Jeffrey (1979), *The Twentieth Century Limited, Industrial Design in America 1925–1939*, Philadelphia.

Mumford Lewis (1946), *Technics and Civilization*, London.

Naylor, Gillian (1985), *The Bauhaus Reassessed*, London.

Nevins, Allan, and Ernest Hill (1957), *Ford: Expansion and Challenge 1915–1933*, New York.

Nye, David E. (1979), *Henry Ford, 'Ignorant Idealist'*, Port Washington, New York and London.

Olsen, Sidney (1963), *Young Henry Ford, a picture history of the first forty years*, Detroit.

Packard, Vance (1963), *The Waste Makers*, New York.

Pagnamenta, Peter, and Richard Overy (1984), *All our working lives*, London.

Pevsner, Nikolaus (1937), *An Inquiry into Industrial Art in England*, Cambridge.

Plunz, Richard (ed.) (1982), *Serge Chermayeff, Design and the Public Good, selected writings 1930–1980*, Cambridge, Massachusettes.

Sloan, Alfred P. (1972), *My Years with General Motors*, London.

Sparke, Penny (ed.) (1981), *Design by Choice*, London.

Sparke, Penny (1987), *Japanese Design*, London.

Sparke, Penny (1988), *Italian Design, 1870 to the present*, London.

Tolliday, Steven, and Jonathan Zeitlin (ed.) (1986), *The Automobile Industry and its Workers, Between Fordism and Flexibility*, London.

Williams, Raymond (1990), *Culture and Society*, London.

Index

Index

Index

Index